GUCCI

gucci.com

#GucciValigeria

Spring 2023
We Make Pictures in Order to Live

Words & Pictures

Front cover:
Mary Manning, from
the series *Grace Is Like
New Music*, 2022
Courtesy the artist
(See page 112)

Opposite:
Yvonne Venegas,
Francisco, 2021, from
the series *Sea of Cortez*
Courtesy the artist
(See page 82)

Subscribe to *Aperture* and
visit archive.aperture.org
for every issue since 1952.

Aperture, a not-for-profit foundation, connects the photo community and its audiences with the most inspiring work, the sharpest ideas, and with each other—in print, in person, and online.

Aperture (ISSN 0003-6420) is published quarterly, in spring, summer, fall, and winter, at 548 West 28th Street, 4th Floor, New York, N.Y. 10001. In the United States, a one-year subscription (four issues) is $75; a two-year subscription (eight issues) is $124. In Canada, a one-year subscription is $95. All other international subscriptions are $110 per year. Visit aperture.org to subscribe. Single copies may be purchased at $24.95 for most issues. Subscribe to the Aperture Digital Archive at aperture.org/archive. Periodicals postage paid at New York and additional offices. Postmaster: Send address changes to Aperture, P.O. Box 3000, Denville, N.J. 07834. Address queries regarding subscriptions, renewals, or gifts to: Aperture Subscription Service, 866-457-4603 (U.S. and Canada), or email custsvc_aperture@fulcoinc.com.

Newsstand distribution in the US is handled by CMG. For international distribution, contact Central Books, centralbooks.com. Other inquiries, email orders@aperture.org or call 212-505-5555.

Become a Member of Aperture to take your interest in and knowledge of photography further. With an annual tax-deductible gift of $250, membership includes a complimentary subscription to Aperture magazine, discounts on Aperture's award-winning publications, a special limited-edition gift, and more. To join, visit aperture.org/join, or contact membership@aperture.org.

Copyright © 2023 Aperture Foundation, Inc. All rights reserved under international and Pan-American Copyright Conventions. No part of this publication may be reproduced in any form without written permission from the publisher.

Credits for "Timeline," pp. 10–11: Evans, American Photographs: © the Museum of Modern Art, New York, and courtesy Art Resource, NY; Evans, Allie Mae Burroughs: Courtesy the J. Paul Getty Museum, Los Angeles; The First Papers of Surrealism: Courtesy David Campany; Levine: © The Metropolitan Museum of Art, New York, and courtesy Art Resource, NY; Curtin: Courtesy the artist; Fallet: Courtesy the artist

Credits for "Curriculum," pp. 28–29: Sanguinetti: © the artist/Magnum Photos; Van Schaick: Courtesy Wisconsin Historical Society, WHI-29148; Goldin: © the artist

Library of Congress Catalog Card No: 58-30845.

ISBN 978-1-59711-547-6

Printed in Turkey by Ofset Yapimevi

OFSET
YAPIMEVİ

Support has been provided by members of Aperture's Magazine Council: Jon Stryker and Slobodan Randjelović, Susan and Thomas Dunn, Kate Cordsen and Denis O'Leary, and Michael W. Sonnenfeldt, MUUS Collection.

aperture

The Magazine of Photography and Ideas

Editor
Michael Famighetti
Senior Managing Editor
Brendan Embser
Assistant Editor
Varun Nayar
Contributing Editor,
The PhotoBook Review
Lesley A. Martin
Copy Editors
Donna Ghelerter, Chris Peterson
Production Director
Minjee Cho
Production Manager
Andrea Chlad
Press Supervisor
Ali Taptık

Art Direction, Design & Typefaces
A2/SW/HK, London

Publisher
Dana Triwush
magazine@aperture.org

Director of Brand Partnerships
Isabelle Friedrich McTwigan
212-946-7118
imctwigan@aperture.org

Advertising
Elizabeth Morina
917-691-2608
emorina@aperture.org

Executive Director,
Aperture Foundation
Sarah Meister

Minor White, Editor (1952–1974)

Michael E. Hoffman, Publisher and Executive Director (1964–2001)

Statement of Ownership, Management, and Circulation (Required by 39 U.S.C. 3685). 1. Publication Title: Aperture; 2. Publication no.: 0003-6420; 3. Filing Date: October 7, 2022 4. Issue Frequency: Quarterly; 5. No. of Issues Published Annually: 4; 6. Annual Subscription Price: $75.00; 7. Complete Mailing Address of Known Office of Publication: Aperture Foundation, 548 West 28th Street, 4th Floor, New York, NY 10001-5511; Contact Person: Dana Triwush; Telephone: 212-946-7116; 8. Complete Mailing Address of Headquarters or General Business Office of Publisher: Aperture Foundation, 548 West 28th Street, 4th Floor, New York, NY 10001-5511; 9. Full Names and Complete Mailing Addresses of Publisher, Editor, and Managing Editor: Publisher: Dana Triwush, Aperture Foundation, 548 West 28th Street, 4th Floor, New York, NY 10001-5511; Editor: Michael Famighetti, Aperture Foundation, 548 West 28th Street, 4th Floor, New York, NY 10001-5511; Managing Editor: Brendan Embser, Aperture Foundation, 548 West 28th Street, 4th Floor, New York, NY 10001-5511; 10. Owner: Aperture Foundation, Inc., 548 West 28th Street, 4th Fl., New York, NY 10001; 11. Known Bondholders, Mortgagees, and Other Security Holders Owning or Holding 1 Percent or More of Total Amount of Bonds, Mortgages, or Other Securities: None; 12. Tax Status: The purpose, function, and nonprofit status of this organization and the exempt status for federal income tax purposes: Has Not Changed During Preceding 12 Months; 13. Publication Title: Aperture; 14. Issue Date for Circulation Data Below: 06/07/2022; 15. Extent and Nature of Circulation (Average No. Copies Each Issue During Preceding 12 Months; No. Copies of Single Issue Published Nearest to Filing Date): a. Total Number of Copies (Net press run): 14,165; 14,923; b. Paid Circulation; (1) Mailed Outside-County Paid Subscriptions Stated on PS Form 3541: 5,701; 5,623; (2) Mailed In-County Paid Subscriptions Stated on PS Form 3541: 0; 0; (3) Paid Distribution Outside the Mails Including Sales Through Dealers and Carriers, Street Vendors, Counter Sales, and Other Paid Distribution Outside USPS: 3,559; 3,374; (4) Paid Distribution by Other Classes of Mail Through the USPS: 10; 10; c. Total Paid Distribution: 9,270; 9,007; d. Free or Nominal Rate Distribution: (1) Free or Nominal Rate Outside-County Copies Included on PS Form 3541: 365; 356; (2) Free or Nominal Rate In-County Copies Included on PS From 3541: 0; 0; (3) Free or Nominal Rate Copies Mailed at Other Classes Through the USPS: 72; 90; (4) Free or Nominal Rate Distribution Outside the Mail: 175; 130; e. Total Free or Nominal Rate Distribution: 612; 576; f. Total Distribution: 9,882; 9,583; g. Copies not Distributed: 4,283; 5,340; h. Total: 14,165; 14,923; i. Percent Paid 93.81%; 93.99%; 16. Electronic Copy Circulation, a. Paid Electronic Copies: 1,032; 1,050; b. Total Paid Print Copies + Paid Electronic Copies: 10,302; 10,057; c. Total Print Distribution + Paid Electronic Copies: 10,914; 10,633; d. Percent Paid (Both Print & Electronic Copies); 94.39%; 94.58%; I certify that 50% of all my distributed copies (Electronic & Print) are paid above a nominal price. 17. Publication of Statement of Ownership: Will be printed in the 03/07/2023 issue of this publication. 18. I certify that all information furnished on this form is true and complete. I understand that anyone who furnishes false or misleading information on this form or who omits material or information requested on the form may be subject to criminal sanctions (including fines and imprisonment) and/or civil sanctions (including civil penalties). Signature and Title of Editor, Publisher, Business Manager, or Owner: Dana Triwush, Publisher, October 1, 2022

aperture.org

Photographer: Christopher Michel / Camera: Leica SL2 / Lense: Leica Vario-Elmarit-SL 24-90mm f/2.8-4 ASPH.

DISCOVER THE LEICA SL-SYSTEM. MADE FOR EXPLORATION.

Test drive the Leica SL-System and discover the creative possibilities.

leicacamerausa.com/test-drive

Boston | Los Angeles | Miami | New York | San Franciso | Seattle | Washington D.C.

HORST P. HORST.

ESSENCE OF THE TIMES

OCT 6, 2022 APRIL 16, 2023

SCAD FASH

MUSEUM OF FASHION + FILM

1600 PEACHTREE ST. NW
ATLANTA

Agenda
Exhibitions to See

Sharjah Biennial

In March 2022, the Sharjah Art Foundation convened the March Meeting, an annual gathering of artists, scholars, and curators, around the theme of the "afterlives of the postcolonial." What would it mean to consider the lasting influence of twentieth-century independence movements in the Global South through the prism of such pressing debates as climate change and Indigenous rights? A multitude of answers might be found in the Sharjah Biennial 15, *Thinking Historically in the Present*, which features the work of more than 150 artists, from the photographers Wendy Red Star and Carrie Mae Weems to the filmmakers John Akomfrah and Isaac Julien. The exhibition was originally conceived by the late curator Okwui Enwezor, who throughout his career expanded the boundaries of international contemporary art, spotlighting artists who often deftly merge aesthetic brilliance with political commitment. Hoor Al Qasimi, the foundation's director, picks up the baton in completing the exhibition and builds on Enwezor's vision "to probe the past, present, and future role that biennials" serve for audiences around the world.

Thinking Historically in the Present at various venues in Sharjah, United Arab Emirates, February 7–June 11, 2023

Ali Omran, Mleiha, Sharjah, 2021
Courtesy Sharjah Art Foundation

Ming Smith, *Womb*, 1992
© and courtesy the artist

Ming Smith

When Ming Smith was a young photographer and newly arrived in 1970s New York, she passed by the Museum of Modern Art and said to herself, "I'm going to be in there one day." She was right. In 1979, Smith became the first Black woman whose photographs were collected by the museum. Over the next four decades, she made images of astonishing range: cover art for jazz albums, spectral silhouettes of city streets, iconic portraits of Sun Ra and Grace Jones, and a series made in response to the plays of August Wilson. This season, Smith returns to MoMA for the exhibition *Projects: Ming Smith*, and the Contemporary Arts Museum Houston presents the career survey *Ming Smith: Feeling the Future*. With a technical mastery that underscores her improvisational energy, Smith has made an evocative, sometimes surreal chronicle of Black life and culture. Belated but timely, both exhibitions stand to reintroduce Smith as a major figure in American art who creates poetic images of rare distinction—a photographer who uses light to affirm self-determination and freedom. "Dealing with light is the main focus and attraction," Smith says. "I do a lot of night shooting, and even in the dark, I look for the light."

Projects: Ming Smith at the Museum of Modern Art, New York, through May 29, 2023, and *Ming Smith: Feeling the Future* at the Contemporary Arts Museum Houston, May 19–October 1, 2023

Georgia O'Keeffe

The iconic twentieth-century American painter Georgia O'Keeffe has been the subject of numerous illustrated books, biographies, and scholarly publications, yet her photography, essential to the story of her art, is relatively less discussed. In photographs that complement her paintings, O'Keeffe demonstrated a sophisticated understanding of light, composition, and form across various media—perhaps best illustrated by her images of the white, trumpetlike jimsonweed flowers outside her house in New Mexico. O'Keeffe took up photography in a serious way only after the death of her husband, Alfred Stieglitz, by which point she had already established herself as a successful painter. In a letter to Stieglitz a few years before his death, O'Keeffe was already writing with a clear photographic vision: "I see the country in its silvery beauty and forbidding blackness in my memory. . . . It is often almost as if I see you too." Currently on display at the Cincinnati Art Museum, and organized by the Museum of Fine Arts, Houston, in collaboration with the Georgia O'Keeffe Museum, Santa Fe, *Georgia O'Keeffe, Photographer* is the first-ever sustained exploration of the artist's photographic work. "O'Keeffe adopted photography in her constant search for expression," notes the curator Lisa Volpe, "capturing the familiar elements of her world in a manner aligned with her larger practice."

***Georgia O'Keeffe, Photographer* at the Cincinnati Art Museum, through May 7, 2023**

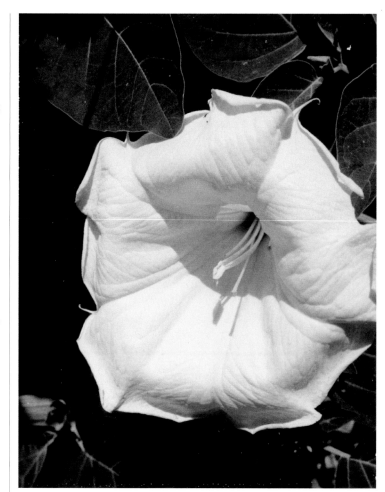

Georgia O'Keeffe, *Jimsonweed (Daturastramonium)*, 1964–68
© Georgia O'Keeffe Museum

Evelyn Hofer, *Greenwich Villagers, New York*, 1964
© Estate of Evelyn Hofer

Evelyn Hofer

One of the most enduring aspects of the photographer Evelyn Hofer's work is her approach to cities. Born in Marburg, Germany, in 1922, Hofer lived across Spain, Switzerland, Mexico, and the United States, and began photographing, first as an apprentice, and then as a professional, in the 1940s. Her photographs of European and American cities—including Dublin, Florence, London, and New York—are now widely known. These images showcase her humane vision and technical virtuosity (Hofer was an early adopter of color photography in the 1960s) across landscapes, architectural views, and, most recognizably, portraiture. She compiled many of these images into photobooks, which form the backbone of her output. "Subtle and rigorous, her photographs possess a captivating stillness, exactitude, and sobriety that ran counter to the dominant aesthetics of the day," says Greg Harris, the curator of *Evelyn Hofer: Eyes on the City*, the first major exhibition of Hofer's photography in the United States in more than fifty years. "As a result, she never achieved recognition commensurate with the quality and originality of her work." Co-organized by the High Museum of Art, Atlanta, and the Nelson-Atkins Museum of Art, Kansas City, the exhibition attempts to rectify this omission, bringing new critical focus to Hofer's pioneering photography.

***Evelyn Hofer: Eyes on the City* at the High Museum of Art, Atlanta, through August 13, 2023**

mpb.com

How much are you holding on to?

Research shows most photographers own a camera or lens they haven't used in two years.

It's quick and easy to turn your extra gear into extra cash. Sell to MPB. Get free doorstep collection and get paid within days.

Scan the QR code
and get a free
quote in seconds

mpb.com

Buy•Sell•Trade
Create ○

Timeline

If Walker Evans's portrayal of Allie Mae Burroughs is an icon of modern photography, it is an unusual one. He made four portraits of her, all slightly different, all circulating as "the one." Evans published and exhibited the versions, often with varying titles and captions. Audiences rarely know which they're seeing. Artists from Surrealism to postmodernism have appropriated them, and Evans's complicated image continues to inspire.

—**David Campany**

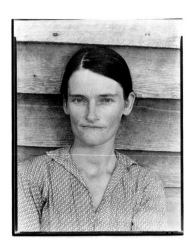

In 1936, while Evans is employed by the US government's Resettlement Administration (later the Farm Security Administration), *Fortune* magazine commissions him and the writer James Agee to document the plight of cotton tenant farmers in the American South. They focus on three families, including Floyd and Allie Mae Burroughs and their children. Evans's 1938 Museum of Modern Art show, *American Photographs by Walker Evans*, and its accompanying catalog, includes a portrait titled *Alabama Cotton Tenant Farmer Wife*.

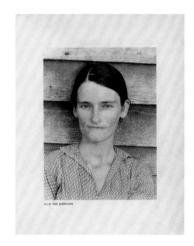

Today, this version is held by the Library of Congress. You can download a high-resolution file, accessible as a public-domain image, on its website.

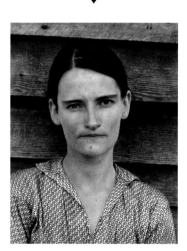

In 2018, the French artist Camille Fallet adds color to several Evans images, including a portrait of Allie Mae Burroughs. (In 1942, Evans had seen one of his images colorized for a wartime government propaganda poster.) Colorizing can have the uncanny effect of making images appear both more familiar and more strange.

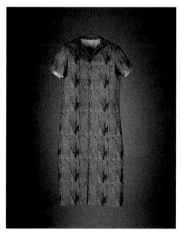

In 2014, the artist Julia Curtin samples Allie Mae Burroughs's dress from one of Evans's portraits, taking photographs of the fabric and re-creating the garment by stitching images together. It is then photographed from four angles and printed close to actual size. In exhibitions, the gelatin-silver prints, titled *Reparation*, are nailed to the wall, unframed, undulating like fragile fabric.

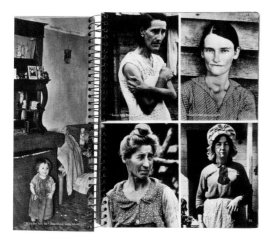

A portrait appears in *U.S. Camera Annual* 1939 in a folio of Farm Security Administration images. It's captioned "Magnificent Propaganda"—words taken from a visitors' comments book at an exhibition of the photographs held in early 1938 at New York's Grand Central Palace.

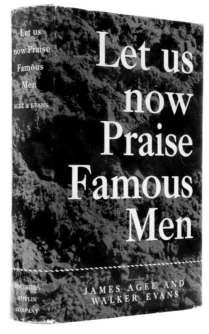

With *Fortune* having rejected the photographs and text, Evans and Agee rework them as the book *Let Us Now Praise Famous Men* (1941). It includes a sterner portrait of Allie Mae, opposite Floyd, within Evans's enigmatic sequence of thirty-two uncaptioned and untitled images. In his text, Agee changes the name Burroughs to Gudger.

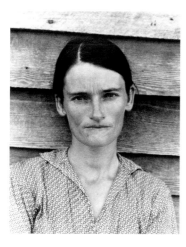

In 1981, the postmodern artist Sherrie Levine rephotographs and exhibits images from the book *Walker Evans: First and Last* (1978). Commentators see the point-blank copying as a feminist riposte to the male modernist canon, although Levine's titling of the image *After Walker Evans: 4* deprives Allie Mae Burroughs of her name. Twenty years on, the artist Jeff Wall recounts: "I interpreted Levine's work as her saying, Study the masters; do not presume to reinvent photography; photography is bigger and richer than you think it is, in your youthful pride and conceit."

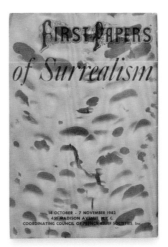

Leonora Carrington

In 1942, Marcel Duchamp and André Breton organize the New York exhibition *The First Papers of Surrealism*. Unable to source images of all the participating artists for the accompanying catalog, they scour books and magazines for "compensation portraits." The painter Leonora Carrington looks a little like Allie Mae. Evans's image is one of three portraits rephotographed from *U.S. Camera Annual* 1939, with its original words cropped off.

David Campany is a writer, curator, and photographer in London.

Make Prints

Edition & Exhibition Printmakers

For Artists & Photographers

60 Freeman Street, Brooklyn, NY

Tel: 646 455 3400 | Email: services@skink.ink | Web: skink.ink

Viewfinder

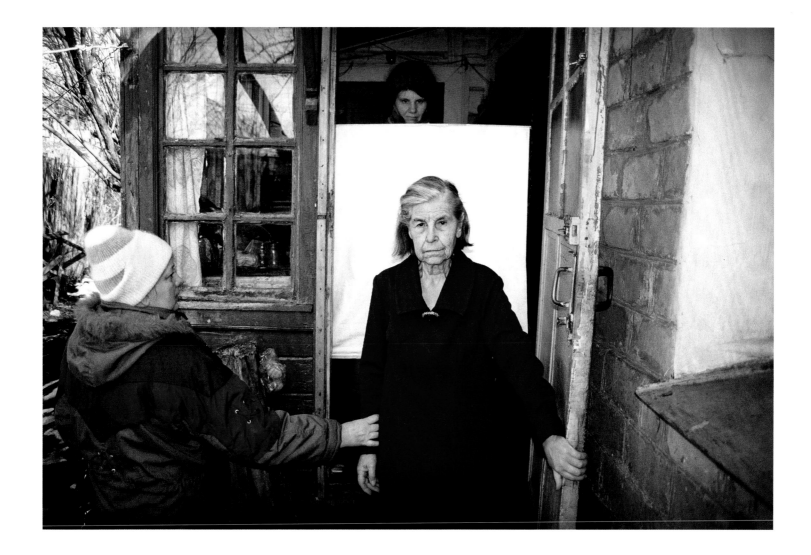

Alexander Chekmenev,
from the series *Passport*,
Luhansk, Ukraine, 1995
Courtesy the artist and Dewi
Lewis Publishing

What do images made before the Russian invasion tell us about the vitality of Ukrainians?

Elianna Kan

A bomb shelter in Kyiv. A mass grave in Mariupol. Bodies of dead civilians strewn on the streets of Bucha. While these pictures of Ukraine have flooded international media and brought the country to the attention of foreign spectators, its struggle for independence and self-determination began long before Russia's full-scale invasion in 2022. Instead of focusing on these images, might a look back to photographic projects predating the present war reanimate the complex richness of the region and pay tribute to the continued vitality of Ukraine's people?

In the mid-1990s, after the fall of the Soviet Union, Alexander Chekmenev took an official assignment on behalf of the newly formed Ukrainian government to make passport photographs of the elderly and disabled in their homes in Luhansk. What he encountered were people in a

Even in scenes of war, there is tenderness. Even in a landscape of political strife, there is whimsy and eros.

state of near total impoverishment who had worked for the government all their lives and received nearly nothing in return. Their Soviet-era apartments were not unlike the one Chekmenev himself had lived in with his grandparents, parents, and sister—often with no running water or gas. Chekmenev's images from these home visits capture a generation largely on the verge of death, untouched by the promise of their burgeoning democratic nation.

Working in black and white with one camera, Chekmenev took the official passport-format headshots of weary visages against a portable white backdrop; while using a wide-angle camera with color film, he captured all that lay beyond in photographs that would eventually form the series *Passport* (1995). "I saw that the frame needed to be widened," he told me

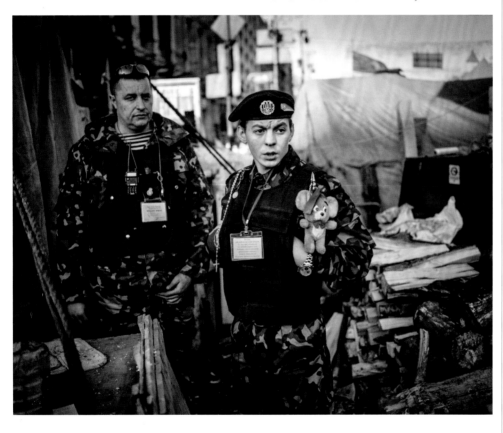

Justyna Mielnikiewicz,
from the series *Ukraine Runs Through It*, 2014-18
Courtesy the artist and MAPS

recently. The photographs represent a people entrenched in an old Soviet system that cared little for, deceived, and effectively abandoned the individual. Depicting a generation trapped in time, the pictures teeter on the precipice of uncertainty.

Chekmenev says he never could have predicted his country's progressive impoverishment, nor that he would become one of Ukraine's most renowned documentarians: his reportage of the 2014 invasion in the Donbas region and, over the last year, portraits from the streets of war-torn Kyiv and of President Volodymyr Zelensky have appeared in publications ranging from the *New York Times* to *Time*

magazine. And could the elderly in his photographs, many of whom had lived through World War II and possibly even Stalin's 1932 forced famine in Ukraine, have predicted that, thirty years after the dissolution of the Soviet Union, Russia would launch a military invasion of their country?

Ukraine Runs Through It (2019), by the Polish documentary photographer Justyna Mielnikiewicz, chronicles mostly the period from 2014 to 2018 and the individuals who took an active part in a major chapter in Ukraine's fight for sovereignty. The book uses the Dnipro River as its conceptual through line—a body of water marking a divide between eastern and western Ukraine, but also muddying the notion of clearly delineated territories. Mielnikiewicz, like many of the protagonists in her images, believes this independence movement represents a shift from seeing Ukraine as a former Soviet country to seeing it as part of a new Eastern Europe: "When you say the new Eastern Europe, it becomes like East versus West, West versus East. Whereas when you say ex–Soviet Union, Russia is somehow always in the center," she explains. Mielnikiewicz's book includes a 2014 photograph of Petro, a young man serving on Ukraine's eastern front. He had joined the protest movement at Maidan Nezalezhnosti (Independence Square) in Kyiv earlier that year and wears a teddy bear pinned to his uniform, a gift from a girl he met at the protests.

Even in scenes of war, there is tenderness. Even in a landscape of political strife, there is whimsy and eros. The artist Julie Poly's project *Ukrzaliznytsia* (2020), with photographs that act as a love letter to the Ukrainian national rail company, where Poly was briefly employed, is an homage to a childhood spent traveling the country by train, observing its landscapes and inhabitants. Flamboyant colors attest to the joyful, coquettish aesthetic of a country of sunflowers and watermelon, cherry jam and pickles. Each train car has its own patterned carpet, baby-pink floral drapes, and faded yellow tables—a Technicolor balm against the drab gray of all things Soviet. The young people she photographed may even refuse to define themselves in any relation to the USSR. A lanky man with a red rose in his hair plays cards with two elderly women, but his gaze is outward, staring at the camera. He's seeing something that they cannot.

Still, in the face of war, Poly responds with eros: she is putting together an erotic magazine, inspired by vintage pinups and

Julie Poly, from the series
Ukrzaliznytsia, 2018-20
Courtesy the artist

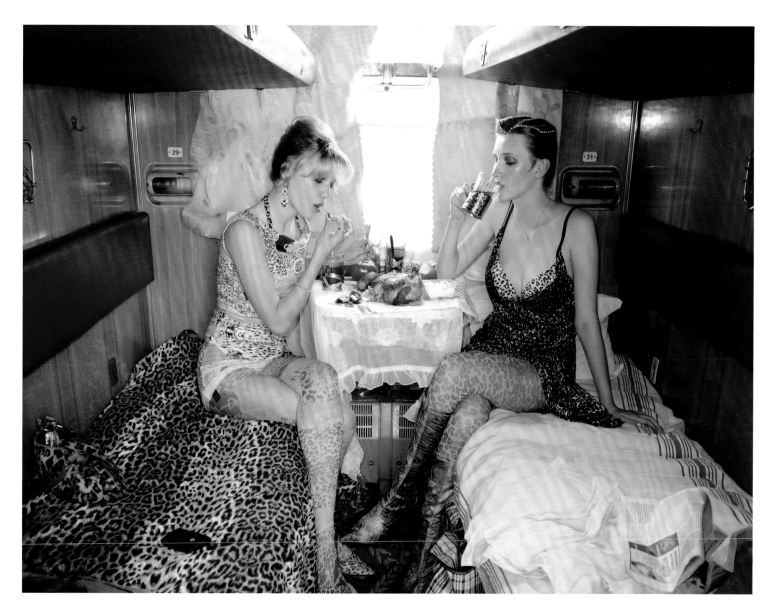

Marilyn Monroe's visit to US troops, which will be sent to Ukrainian soldiers on the war front. When Russian air strikes began in 2022, Poly fled Ukraine while eight months pregnant. Now residing in Germany, she continues to be optimistic that life in Kyiv will return to its previous vibrancy. She looks at her photographs from *Ukrzaliznytsia* with nostalgia and admiration. "Ukrzaliznytsia is still transporting people, but now in the context of evacuating them," Poly says. "The book itself feels like a testament of the past, but I hope these journeys will start up again. I hope these colors, these patterns, these people, the smiles on their faces will all return."

Viewed together, the works of Chekmenev, Mielnikiewicz, and Poly generate a kind of "alternative photography," as the critic John Berger once called for—a photography that instead of freezing images in time returns them to a living context, reintegrating the past into the present for the preservation of socio-political memory. More than mere spectacle, these photographs bear witness to a people immersed, consciously or unconsciously, in emergent history—one in which individual stories play out against the backdrop of a nation's ongoing becoming and its striving to define its sovereignty.

Elianna Kan is a writer and translator based in Mexico City and New York.

Spring/ Summer 2023 Books

Zhang Xiao: Community Fire
Photographs by Zhang Xiao
Essay by Ou Ning
Copublished by Aperture and
Peabody Museum Press
US $65.00 / UK £50.00

Awol Erizku: Mystic Parallax
Works by Awol Erizku
Essays by Ashley James, Ishmael Reed,
and Doreen St. Felix
Interviews with the artist by Urs Fischer
and Antwaun Sargent
US $75.00 / UK £60.00

Ed Templeton: Wires Crossed
Photographs by Ed Templeton
Interviews with Brian Anderson, Erik Ellington,
Justin Regan, Elissa Steamer, Deanna
Templeton, and the artist
US $60.00 / UK £45.00

Ari Marcopoulos: Zines
Photographs by Ari Marcopoulos
Interview by Hamza Walker
Essay by Maggie Nelson
US $60.00 / UK £50.00

**Strange Hours: Photography,
Memory, and the Lives of Artists**
An Aperture Ideas Book
Selected writings by Rebecca Bengal
Foreword by Joy Williams
US $29.95 / UK £22.00

Kimowan Metchewais: A Kind of Prayer
Photographs and texts by
Kimowan Metchewais
Texts by Christopher T. Green, Emily
Moazami, and Jeff Whetstone
US $75.00 / UK £60.00

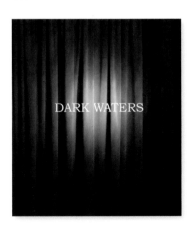

Kristine Potter: Dark Waters
Photographs by Kristine Potter
Short story by Rebecca Bengal
US $65.00 / UK £50.00

Tommy Kha: Half, Full, Quarter
Photographs by Tommy Kha
Interview by An-My Lê
Essay by Hua Hsu
US $60.00 / UK £45.00

Shop: aperture.org/books

Dispatches

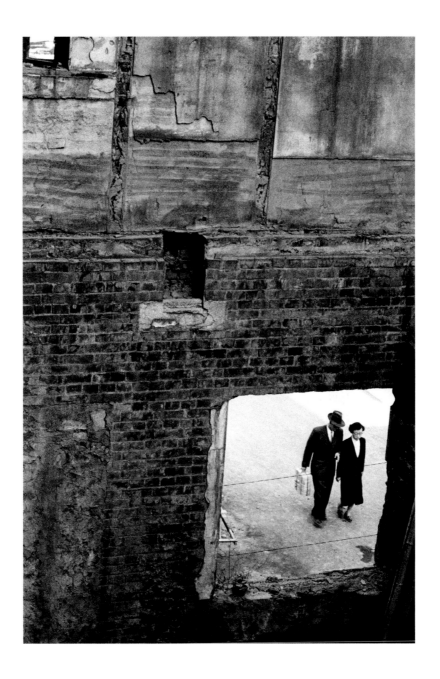

For decades, photographers have chronicled the staggering changes to Seoul, a metropolis in transition—and a new center for the art world.

Andrew Russeth

Even after two years of living in Seoul, I'm continually astonished by the famous pace of change here. Chic coffee shops alight, rebrand, and disappear almost overnight. Chunks of a neighborhood will suddenly be fenced off, bulldozed, and readied for development. A map of the subway system that I bought when I first arrived is already out of date, missing the latest stops—something truly bizarre to a longtime New Yorker.

The capital city's art scene has been undergoing quicksilver changes, too, as

big-league international galleries such as Gladstone, König, Tang, and many more have opened branches. To get a sense of just how remarkable the shifts of recent decades have been, I recently looked back at the sparkling on-the-street photographs that Han Youngsoo made in Seoul in the 1950s and 1960s, just after the Korean War. These black-and-white images find a city thrumming with activity—and preserve a way of life that has long since vanished. Women and girls balance laundry baskets atop their heads along the Han River

as clothing dries on a nearby rock. Tiny houses dot a city hill. Pedestrians dodge wheeled carts, automobiles, and trolleys, which would stop running in 1968. A concise survey of Han's work at Gallery2 in Jeju City this past summer was aptly titled *Once Upon a Time*.

Born in 1933, Han fought for South Korea in the war and was part of the generation that, amid a tense truce and military dictatorship, would begin to build the country into an economic dynamo. Perhaps fittingly, in the mid-1960s, he

While Kim's photographs may not have an immediate political impact, they are indelible documents of people fighting together.

shifted his practice, opening a studio for advertising and other commercial projects. He died in 1999. It's intriguing to imagine what Han might have done had he kept pounding the pavement. He had patience, wit, and a way with people. He spots a young Asian girl glancing at the Caucasian mannequins in a shop window. A young boy wearing a frightening mask faces the photographer square on as his father takes a smoke break.

The definitive Han shot? My vote is for a 1956 work, caught from a few stories aboveground in Myeongdong, which today is a bustling retail neighborhood. His camera peers down through a big square hole in a dilapidated building just as a natty couple walks along the sidewalk— an uneasy metropolis in transition, its denizens on the move.

Around a half century later, Che Onejoon began recording traces of that tumultuous era and the continuous remaking of Seoul in deadpan, large-format photographs that are absent of people but also strangely tender in their careful framing and vivid details. He has brought his camera to underground bunkers, government buildings, and US and South Korean military bases in and around Seoul, often focusing on spaces that are unused, underused, or forgotten. One

project leads to another. "It's like a tree," Che says of his practice. "Naturally, it has grown up." He notes that, unintentionally, he was "demonstrating all the sites for developing apartment complexes." In Korea, everything eventually becomes an apartment development.

When an antiprostitution law was enacted in 2004, Che headed to Miari Texas, the city's largest red-light district, parts of which had been marked for redevelopment. He photographed the interiors (pillows, mirrors, and odd lighting predominate) of sex-work businesses, including some that had been abandoned, and razed lots. "I was able to document the demolition of the landscape," he states.

Lately, Che has been living in Dongducheon, a city just north of Seoul, where he co-runs a venturesome nonprofit gallery called Space AfroAsia and helps African immigrants who have settled in the city deal with the logistical issues of living somewhere new. It's the latest unusual chapter in an unusual career. Che learned photography at a vocational school. While doing the mandatory military service required of all Korean men, he was directed to wear civilian clothes and take pictures of protests, collecting evidence of people carrying

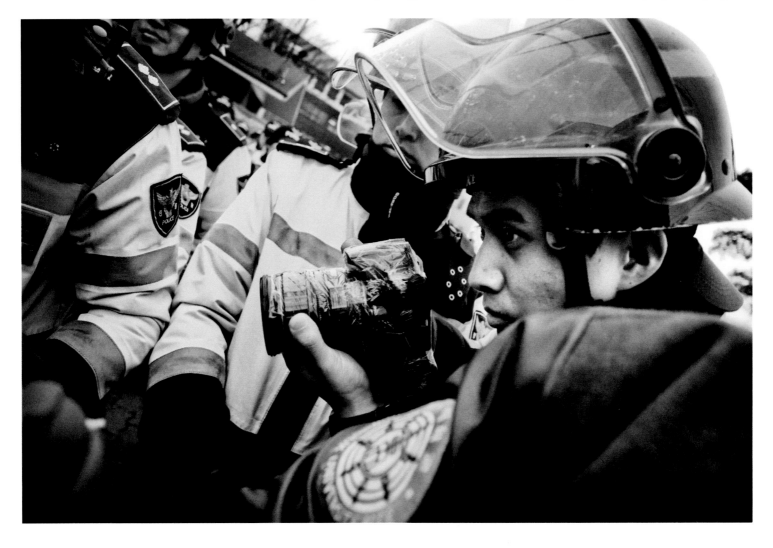

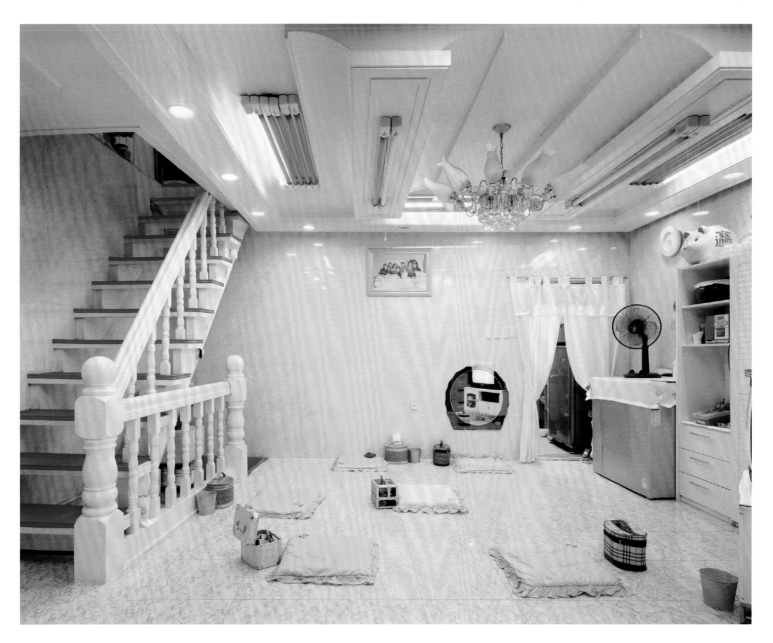

illegal weapons. "I was kind of an undercover cop," he says.

The photographer Kim Min has been on the other side of such police observation. Born in the southwestern city of Jeonju, he came to Seoul in 2011 and got involved in protests in support of organized labor and antigentrification efforts. (That year, he was part of a squat at a café to fight evictions—in Myeongdong, as it happens.) In his *Yes_We_Cam* series (2012–16), which appeared in the 2021 Seoul Mediacity Biennale, Kim trained his lens on the cameras of the police. Video recorders on poles loom over crowds and menacing officers in riot gear brandish bulky DSLR cameras.

Kim favors black-and-white, high-contrast, close-up images, which make you feel like you are right alongside him. Most of the policemen documenting the protests appear bored, though a few have looks of smug satisfaction, perhaps knowing that if their presence does not keep people in line, the visual evidence will doom them later by providing identification at trials. Kim himself was indicted for blocking a road at a protest. Naturally, he scanned and printed photographs of the paperwork and police-furnished photographs, creating a wry mise en abyme of state surveillance.

Like Che, Kim no longer lives in the city he has so ably recorded for years—he's in Ilsan, to the northwest. "I moved because Seoul was just way too expensive to live in," he says. A conscientious objector to military service, he is preparing for alternative service and planning new photobooks of his work.

"I tried to share whatever I saw on the street, while squatting, and at protests," Kim explains. "I would take a photo with my smartphone and post it quickly on Twitter." A decade ago, amid the Arab Spring and other movements facilitated by social networks, he saw heady potential in such activities. He is less sanguine now. "Especially at this moment, the myth of democratization of photography and the roles of social networking services in revolution are dead," he says. "This is an era of information overload, disinformation, and algorithm-selected recommended content."

But while Kim's photographs may not have an immediate political impact, they are indelible documents of people fighting together. In some, no signs or banners are visible, and therefore they carry a kind of universality as they radiate the thrill of action. They show brave people who are marching, and chanting, and demanding change that will not occur until, all of a sudden, it does.

Andrew Russeth is a critic based in Seoul and a contributor to the *New York Times*.

In her airy live-work loft high above the cacophony of downtown New York, Rosalind Fox Solomon reflects on her decades-long career.

Tiffany Lambert

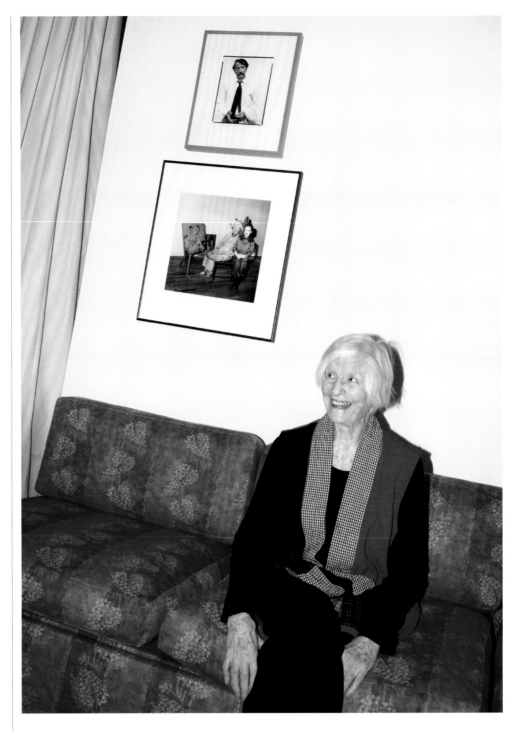

Rosalind Fox Solomon and her home studio, New York, October 2022
Photographs by Jason Nocito for *Aperture*

Rosalind Fox Solomon's home and studio are on an upper floor of an eight-story former commercial building in the NoHo Historic District of New York. Completed in 1893 and named by the Landmarks Preservation Commission in 1999, it was designed by the German American architect Alfred Zucker at a time when the area's Federal-style mansions were being replaced by high-rise structures.

Fox Solomon has lived and worked inside Zucker's iron, granite, and terracotta building on Broadway since 1984. Her loft is a treasury for a nomadic life spent traveling around the world taking photographs of people—meeting them where they live. For more than fifty-five years, she has built an affecting body of images attentive to the human condition, probing its vulnerability and struggles, scrutinizing the pleasures and toxicities that define us. "What I was interested in was psychological . . . what was going on inside people," Fox Solomon told me.

Entering for a recent visit, I'm greeted by the photographer's cat, Little Lady Lola, and immediately encounter a large sculpture, of human height, created by the artist in 1980. Titled *Adios*, the piece (something of an homage to her divorce around that date) is based on tombs in Peru. "I really loved working there," Fox Solomon says. "At that time, people came to mountain climb; otherwise there weren't any tourists. It was kind of untouched." Fox Solomon has traveled extensively throughout the United States, as well as to remote places in Asia and Latin America. The studio's walls are filled with her own images, interspersed

with art and objects collected on the many trips. Portraits by Julia Margaret Cameron and Richard Avedon—of John Szarkowski—also adorn the walls.

Born in a Chicago suburb in 1930, Fox Solomon began photographing with an Instamatic camera at the age of thirty-eight while living in Chattanooga, Tennessee, with her then husband and two children. While participating in a cultural exchange program called the Experiment in International Living, she cultivated an interest in travel and photography. On a visit to New York, she was introduced to Lisette Model, the legendary Austrian-born American artist who helped redefine street photography. In 1974, Fox Solomon began studying privately with Model, continuing until 1976. A mere decade later, the Museum of Modern Art organized *Rosalind Solomon: Ritual*, an exhibition of thirty-four pictures made between 1975 and 1985.

Her photographs complicate and layer meaning, challenging viewers to go beyond familiar narratives. Early examples taken in the 1970s pointedly capture the legally desegregated but still racially divided American South, a place Fox Solomon would photograph into the 1990s. A collection of these images is featured in the book *Liberty Theater* (2018), named

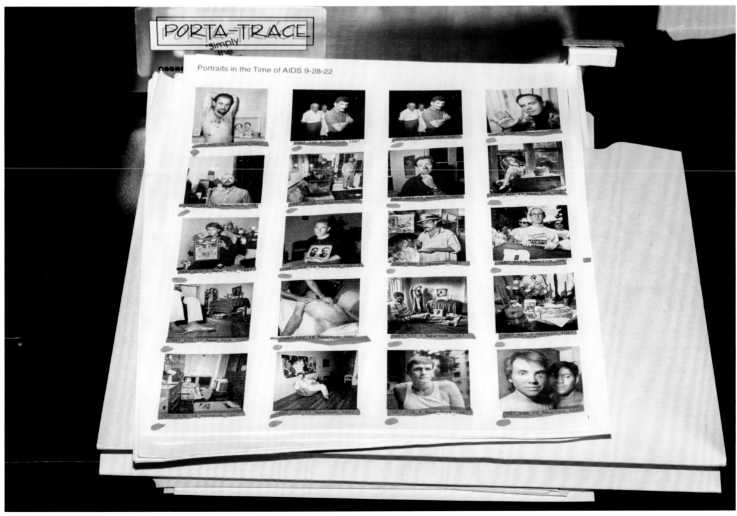

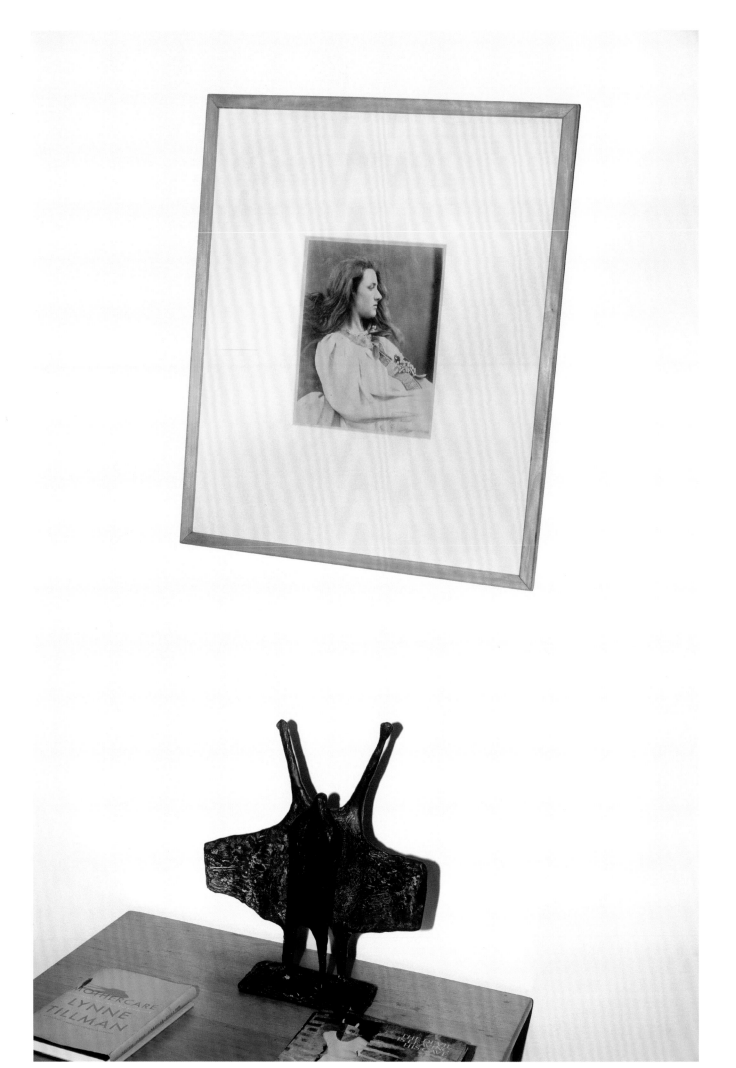

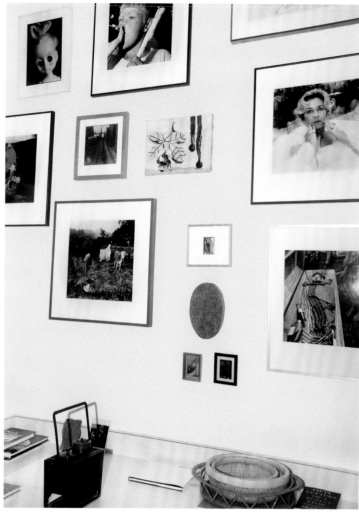

At ninety-two, Fox Solomon shows no signs of slowing down.

after one of the last cinemas in Chattanooga to remain segregated. Abroad, Fox Solomon made photographs that depict cultures and locations amid political strife—violent terrorism in Peru, apartheid in South Africa, ethnic violence in Northern Ireland—but that move beyond conventional documentary description to work that is suggestive of her relationship with her subjects. "I don't like to talk too much to people when I'm photographing because I'm interested in reaching the interior. I don't want them to be functioning on a superficial level," she says.

At ninety-two, Fox Solomon shows no signs of slowing down. Her groundbreaking and intimate project *Portraits in the Time of AIDS* (1987–88), first exhibited at the Grey Art Gallery at New York University, three blocks from her apartment, was recently acquired by the National Gallery of Art. Last year's edition of Paris Photo included a solo exhibition, organized by MUUS Collection, of Fox Solomon's early series from the 1970s portraying scenes at a flea market in Scottsboro, Alabama. She is currently focused on a new book due out this year. "I'm enjoying having my work get out the way it's been getting out," she says. "It's exciting to have all this going on at my age. I'm really fortunate to have

lived to see this recognition. It's kind of beyond belief."

Never one to photograph commercially, and rarely on commission, Fox Solomon has had a prolific career that includes more than thirty solo exhibitions and a hundred group shows; her work is held in prominent museum collections worldwide. Even decades after she photographed them, Fox Solomon's remarkable pictures continue to hold their power. They are as much about the subjects and how they see themselves as they are about how we see and understand the subjects. Her particular method of portraiture urges us to examine people and our preconceptions more carefully.

"If I had the courage, today I would go photograph people on the extreme right. That's what I would be attracted to doing," says Fox Solomon. "And probably I could do it because I'm old and nobody would think of me as dangerous. That was how I did a lot of my work. Because I was always older and I just don't think that people were afraid, although I think they could have been."

Tiffany Lambert is a curator and writer based in New York.

Backstory

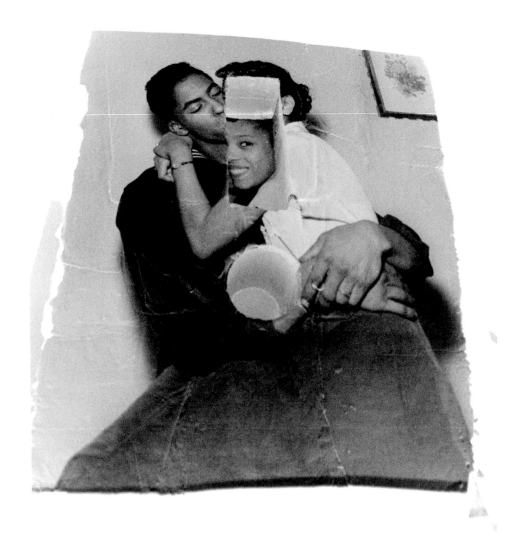

Before he died in the early 1990s, Darrel Ellis made experimental images with family pictures. Will a retrospective revive interest in a nearly forgotten artist?

Max Pearl

In 1979, Darrel Ellis and another artist named James Wentzy applied for a P.S.1 Contemporary Art Center studio residency, still a fledgling program at the time. Ellis had been out of high school for only three years, and he'd worked mostly in painting and illustration. But when the two got to the defunct school that had become P.S.1, in Long Island City, they built a makeshift darkroom where Wentzy taught Ellis to develop and print his own photographs. The furnace at P.S.1 would shut off at five o'clock each afternoon, but Ellis lived there for two years anyway,

often wearing a coat and gloves inside. It was here that he and Wentzy devised the approach that would become Ellis's calling card, of projecting negatives onto unevenly shaped sculptural forms to produce strange and illusory distortions.

As source material, Ellis used mostly family photographs taken by his father, who was tragically killed by police in a street altercation before Ellis was born. For Ellis, these placid pictures of family get-togethers represented a kind of prelapsarian peace he never knew, having

This page:
Allen Frame, *Darrel Ellis,
my apartment, NYC*, 1981
© the artist and courtesy
Gitterman Gallery

Opposite:
Darrel Ellis, *The Kiss*, 1990
Courtesy Galerie Crone,
Berlin and Vienna, and Darrel
Ellis Estate, New York

grown up in the "Bronx is burning" era. After transforming the images into serial variations, he would reproduce them as paintings and watercolors, a process he referred to as deconstruction and reconstruction. These enigmatic sequences are the main attraction at the late artist's first-ever museum retrospective, *Darrel Ellis: Regeneration*, a collaboration between the Baltimore Museum of Art, where it opened in 2022, and the Bronx Museum of the Arts, where it goes on view this summer.

The show has come together, in part, through the advocacy of Ellis's friend Allen Frame, an artist and curator who began compiling the work when Ellis died, of AIDS-related causes, in 1992. Frame has been trying to secure Ellis's legacy ever since. He curated a 1996 retrospective at the Manhattan space Art in General that traveled and received favorable reviews, but he later found it hard to get dealers and collectors interested. "The fact that he was using family photographs may have confused people at a time when that kind of imagery and photography was not so welcome," Frame recently told me. "For most of the '80s, the idea of photographing your friends and family was still not seen as legit in fine-art circles."

Then, around 2015, the curator Drew Sawyer happened upon one of Ellis's photo-projection pieces, which the Museum of Modern Art had purchased for its *New Photography 8* show in 1992, in MoMA's collection. The uncanny image, *Untitled (Mother)* (1990), depicts the artist's mother against a neutral photo-studio background, her eyes and forehead redacted by a vaguely ominous floating rectangle. Sawyer pitched a show to the art space OSMOS that went up in New York in 2019, kicking off a posthumous career revival for Ellis.

At the Baltimore Museum of Art, the work was presented in the Cone Wing, which is typically reserved for nineteenth- and early twentieth-century European art: the period that most inspired Ellis. From frequent visits to hallowed Manhattan museums, he discovered that his artistic vision shared many concerns with turn-of-the-century painters such as Édouard Vuillard, who depicted the quiet magic of interior and domestic scenes.

After Ellis's P.S.1 residency, he was accepted, in 1981, into the Whitney Independent Study Program—the only participant that year without a college degree—where he read poststructural theory, which got him thinking about the

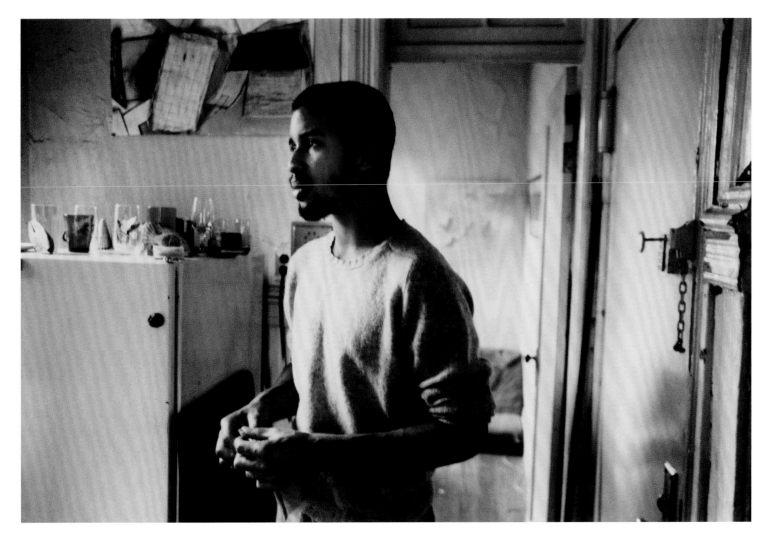

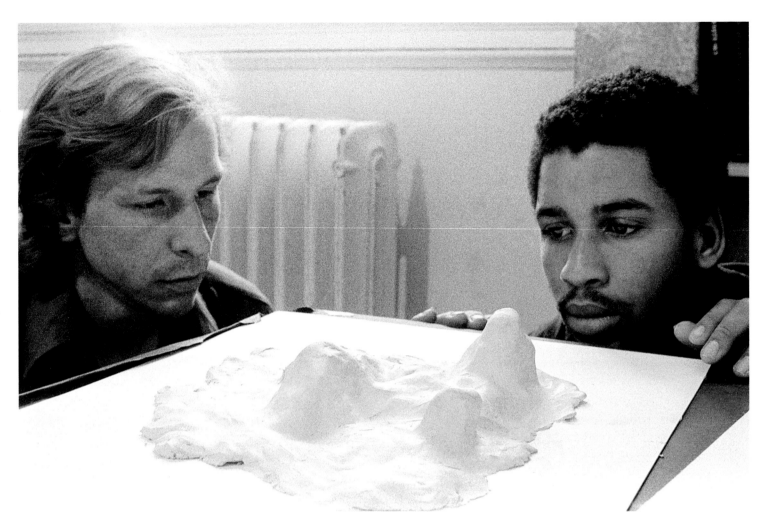

James Wentzy and Darrel
Ellis in their studio at P.S.1
with a plaster projection
surface used for their
experimental photographs,
1979. Photograph by
James Wentzy
Courtesy the artist and Visual
AIDS

Rediscovery isn't as simple as it might seem, especially for gay artists such as Ellis who didn't live to see their work celebrated.

semiotics of photography and sculpture. Many of his photo-projection pieces are mind-bending object lessons about the thingness or materiality of the surface itself, especially such works from the late 1980s and early 1990s as *The Kiss* (1990).

For some black-and-white prints, Ellis projected a studio portrait of his mother and sister onto a surface of scooped-out squares and circles, causing their faces to be swallowed by light. He would create third-generation renderings of these second-generation images by painting the photograph of the projection on canvas. The result is a profound disorientation, as in the painting *Untitled (Mother, Father, and Laure)* (ca. 1990), which has the what-is-even-real effect of trompe l'oeil. *Regeneration* includes full displays of some of these works so viewers can see how Ellis's ideas developed from one medium to the next.

"Reading his notebooks, it's clear Ellis had a conceptual vision of how he wanted his work presented, which was to show it in all of its plurality," says the exhibition's cocurator Antonio Sergio Bessa. "We hope that by displaying some of the complete sequences, we can present the complexity of that vision."

It's hard to know why the wider art world took so long to acknowledge that vision. Rediscovery isn't as simple as it

might seem, says Allen Frame, especially for gay artists such as Ellis who didn't live to see their work celebrated. "In the aftermath of the AIDS pandemic, a lot of estates needed to be attended to," he explains. "And not only that, but there was a lot of exhaustion and fatigue around it." It may have taken thirty years, but the slight has finally been amended, and there's no feeling like watching art history rewritten before your eyes.

Darrel Ellis: Regeneration is on view at the Bronx Museum of the Arts from May through August 2023.

Max Pearl is a writer and translator based between the United States and Mexico.

Curriculum
Alessandra Sanguinetti

As a child growing up in Argentina, Alessandra Sanguinetti came under the spell of illustrated books, from classics by Dorothea Lange to Time Life compendiums. When she began to make pictures, a curiosity about life in rural communities and how people connected to the land drove her vision. These projects led to a tender and ambitious chronicle of the evolving relationship of two young girls through adolescence and into young adulthood. Sanguinetti recently published *Some Say Ice* (2022), a disquieting gothic set in small-town America, inspired by *Wisconsin Death Trip*, Michael Lesy's macabre cult classic of nineteenth-century archival excavation. Sanguinetti's riff may be contemporary, but it's just as eerie.

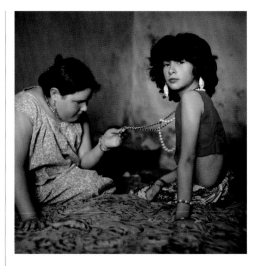

Juana Navarro de Falconet and her diaries

Juana lived a few kilometers from our farm, south of Buenos Aires. I met her when I was still a teen. Her place was a constant cacophony of animals going in and out of the kitchen, hanging from hooks, in cages, on her lap—animals in every state, from bliss to slaughter. She would speak of them in a loving manner that I was not used to hearing from farm people. Juana also kept a diary. Each entry began with a description of the weather, followed by the goings-on of her animals and family, and a drawing or two. She always had both animal and people gossip. It was through Juana that I met her granddaughters, Guille and Belinda, whom I would photograph over many years.

Fernando Pessoa

Discovering Fernando Pessoa when I did, during a bit of a dark period, was like finding a long-lost best friend who could unfailingly articulate what I couldn't put into words, along with thoughts I didn't even know I had. There's no narrative in *The Book of Disquiet* (1982). Its disconnected texts were written over Pessoa's lifetime and gathered together much later. It's a non-autobiography that speaks mostly to the meaninglessness of life but still has the effect of making me feel very alive and connected.

Leonardo Favio and Werner Herzog

El romance del Aniceto y la Francisca (The Romance of Aniceto and Francisca, 1967), by Leonardo Favio, is a long, languid poem of a movie. A classic tale of love gone wrong, set against the backdrop of a sleepy provincial town in Argentina. In it, I saw rural towns, like those I knew, depicted on a big screen so accurately, heavy with melancholy and dread. *Stroszek* (1977) by Werner Herzog is just pure wild poetry. I could watch Bruno and the dancing chickens, the auction guy, and the truck going around in circles at the end a million times. I can't say why I love this movie so much. All I know is that it exhilarates me and makes it okay that nothing makes sense.

This spread, clockwise from top left: Alessandra Sanguinetti, *The Necklace, Buenos Aires, Argentina*, 1999; Charles Van Schaick, *Portrait of Eight Women and One Man*, from Michael Lesy, *Wisconsin Death Trip* (1973); Nan Goldin, *David Wojnarowicz at Home*, New York City, 1991; Cover of Sally Mann, *At Twelve: Portraits of Young Women* (Aperture, 1988); Werner Herzog, still from *Stroszek*, 1977; Cover of Fernando Pessoa, *The Book of Disquiet* (1982)

The Best of Life and *Wisconsin Death Trip*

I promise I didn't notice the irony of these titles together until I listed them here. These two books were on my family's coffee table when I was growing up in the 1970s, in Buenos Aires. *The Best of Life* (1973) is a glossy, kaleidoscopic photographic history of the twentieth century from *Life* magazine. It enthralled me. In that book alone I could see instructions on how to undress in front of your husband, images of the moon landing, and Marilyn playing it up for Avedon, as well as graphic depictions of war and natural disasters. Its pages made photography seem like a magical, time-traveling vehicle. Michael Lesy's *Wisconsin Death Trip* (1973) also loomed large in my childhood. Those somber, now dead people terrified and intrigued me. The girl in the coffin opposite the mummified-looking old lady was momentous. I realized I was going to die, and my response was literal. I asked for a camera. I wanted to make really sure that in one hundred years people would know that my family and I had existed.

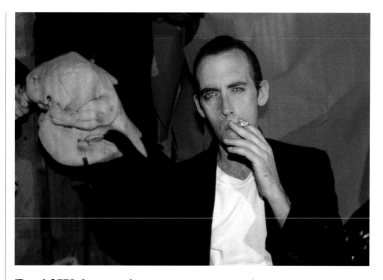

David Wojnarowicz

I saw David Wojnarowicz's work in the early 1990s and was blown away. This was the most visceral combination of personal and political art I'd ever experienced. At once gentle, angry, tender, and urgent. Not an ounce of it was made to please or to show off, to impress or to sell. Then, of course, there's *Close to the Knives* (1991), his furious, radiant masterpiece of a memoir. Even though his style couldn't be more different from mine, he's always been a North Star.

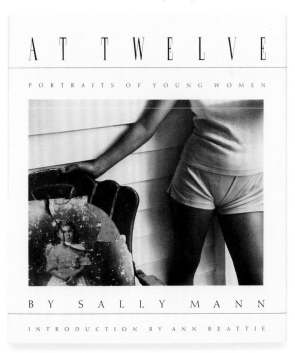

Sally Mann

Sally Mann's *At Twelve: Portraits of Young Women* (1988), with its gorgeous, moody pictures, was the first book in which I saw young girls portrayed as complex, individual, and deeply human. Each portrait feels like the start of a great novel. The girls are on the brink, brimming with secrets we'll never know.

Nick Waplington,
***Untitled*, from the series
New York Club, 1994**
Courtesy the artist
(See page 54)

We Make Pictures in Order to Live

We tell ourselves stories in order to live. This simple yet powerful declaration, a mantra even, opens *The White Album*, Joan Didion's quintessential 1979 collection of essays. Following that first line is a series of sentences conjuring narratives that read with the clarity of a photographic or cinematic still: "The man with the candy will lead the children into the sea."

Until her death in 2021, Didion held titanic sway over the American literary scene—and her distinctive appearance traveled into the broader public imagination. She was often portrayed by celebrated photographers, becoming an iconic, self-styled image in her own right. Though Didion didn't write much about photography, unlike her contemporaries Susan Sontag and Janet Malcolm, her prose did something photographic through its crystalline rendering of thorny realities and the flotsam and jetsam of human experience. "We live entirely, especially if we are writers, by the imposition of a narrative line upon disparate images," she wrote, "by the 'ideas' with which we have learned to freeze the shifting phantasmagoria which is our actual experience."

Many photographers might recognize their work, processes, and motivations in those words. A narrative structure may be followed or dismantled. An image can invent a fiction, communicate a version of the truth, or, more often, linger in the peculiar, ambiguous space between the two. In this issue, which arrives at a moment when Didion's legacy is considered by a recent exhibition in Los Angeles and an auction of her personal effects, including an admirable selection of artworks, our contributors explore the quiet poetry—or the clamorous disorder—of the everyday. They write communities into history, invoke folkloric traditions, question their authority as artists, collaborate with their subjects, or create records of lived experiences that are sometimes discovered and understood only decades on. They show how making photographs is a way of being alive and attuned to the frequencies around us. —**The Editors**

The Afterimage of Joan Didion

Aside from portraits capturing her own nervy glamour,
how might we consider Didion through photography?
Brian Dillon

**Bridgette Lacombe,
contact sheet of Joan
Didion (detail), 2011**
Courtesy the artist
and Lacombe, Inc.

"My mind veers inflexibly toward the particular," Joan Didion writes in her 1965 essay "On Morality." When it comes to the concrete and specific, you might say there's a continuum among her cohort (now mostly gone) of great American essayists. At one end, Susan Sontag's epigrammatic judgments, with their relative lack of empirical texture. In the middle, Janet Malcolm's fine attention to peculiarities of person or place. Then there is Didion, out along her own axis, where the essay is almost all detail. Sontag and Malcolm wrote extensively about photography. Didion, very little. But such is her mix of vision, exactitude, and atmospheric effect that her work seems more suited than that of others to sit alongside paintings, drawings, and photographs, with an eye toward making connections. In their introduction to the catalog of *Joan Didion: What She*

Ed Ruscha, *Santa Monica Boulevard, 1974: Roll 11: Overland headed west: Image 0105*, 1974
© the artist and J. Paul Getty Trust, Los Angeles

Means—a recent exhibition at the Hammer Museum, University of California, Los Angeles—the show's curators, Hilton Als and Connie Butler, speak of Didion's "acutely visual language." What does that mean?

Als, a friend and literary peer of Didion's, has previously put together exhibitions about James Baldwin and Toni Morrison, authors whose power and presence we may imagine we glimpse in photographs of them. But Didion is something else: a writer whose talismanic image—in life, and even more so since her death, in December 2021—is the object of feverish projection and surmise. No wonder, when we survey celebrated portraits of her. In 1996, she sat for Irving Penn, who seems to have noticed that in many photographs of Didion it's her thin, bare arms that do the work of conveying brittle thought processes. Brigitte Lacombe photographed her in the same year as Penn: here, Didion vanishes into her turtleneck sweater but remains unmistakable thanks to hands and hair. A photographic ideal of the writer was already present in Julian Wasser's 1968 studies of Didion leaning against her new Corvette Stingray. The ideal was still there in 2014 when Juergen Teller photographed her for a Céline advertising campaign: sunglasses, helmet of silver hair, birdlike (always this adjective) limbs inside simple clinging black.

Somehow, we have come to think of Didion as a writer whose photographic imago incarnates certain features of her prose, oversensitive but unsentimental, held together in the face of personal or cultural catastrophe—above all, *cool*. Since her death, there's been an extraordinary poring over of period ephemera, including a *Vogue* photograph of her kitchen countertop in 1972, along with Didion's stationery preferences and taste in glassware—these last thanks to online images from her estate sale. A curious way to commemorate a writer who, in 1979, while reviewing films by Woody Allen, despaired of a culture hooked on minor signifiers

A composer, on the page, of indelible pictures, Didion was also highly suspicious of image making.

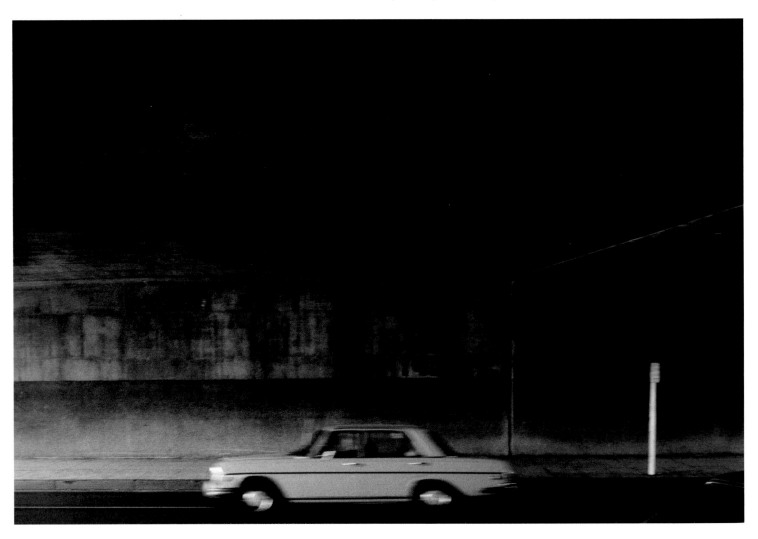

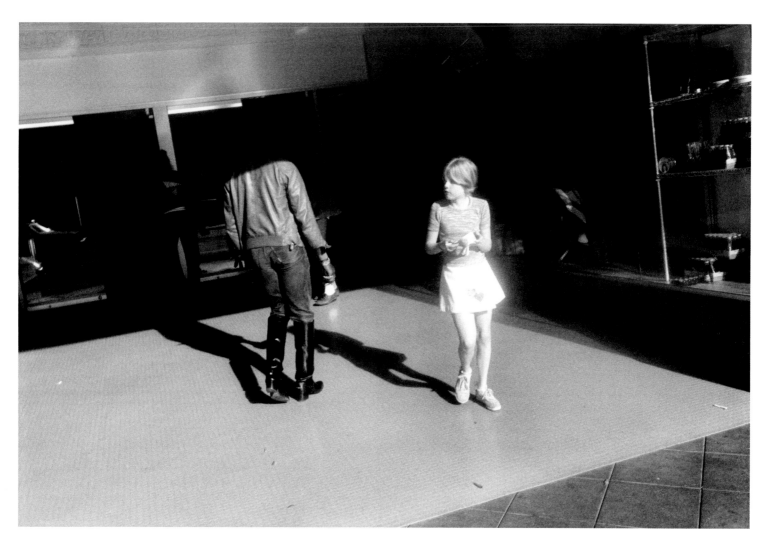

Garry Winogrand, *Beverly Hills, California*, 1978
Courtesy the Estate of Garry Winogrand and Fraenkel Gallery

Right:
Cover of Joan Didion, *The White Album* (Simon and Schuster, 1979)
Courtesy Left Bank Books

of self-image: "a subworld of people rigid with apprehension that they will die wearing the wrong sneaker."

A composer, on the page, of indelible pictures, she was also highly suspicious of image making as such. One of the few pieces in which she writes directly about photographs is "Some Women," a 1989 essay on Robert Mapplethorpe. It's an oddly evasive text—the artist "struggling with illness" rather than dying of AIDS, his sexuality euphemized in the phrase "Rimbaud of the baths." But she begins the essay with a frank reflection on time spent around photographers and their celebrity subjects when she worked at *Vogue* in the late 1950s and early 1960s. It seemed to the young Didion, part of whose job was to write captions for the magazine's photo spreads, that photography was a matter of power and lies: "Success was understood to depend on the extent to which the subject conspired, tacitly, to be not 'herself' but whoever and whatever it was that the photographer wanted to see in the lens."

Aside from photographs capturing her own nervy glamour, what images come to mind when we think of Didion's writings? Some snapshots from the more celebrated essays: The early-morning drinker in a Wilmington, Delaware, hotel bar, wearing a dirty crepe de chine wrapper, who says: "That woman Estelle is partly the reason why George Sharp and I are separated today." A Volkswagen in flames on the freeway, and the murdering wife in her too-fancy courtroom outfit. A three-year-old on acid.

American mundanity, obscenity. "It so happens that if you're a writer the extremes show up," Didion tells us. In the Hammer Museum catalog, a Warhol electric chair occupies a left-hand page; on the right, photographs by William Eggleston of a Spanish-style veranda, an empty swimming pool in sunlight. The tensions in Didion's writing are usually subtler than this

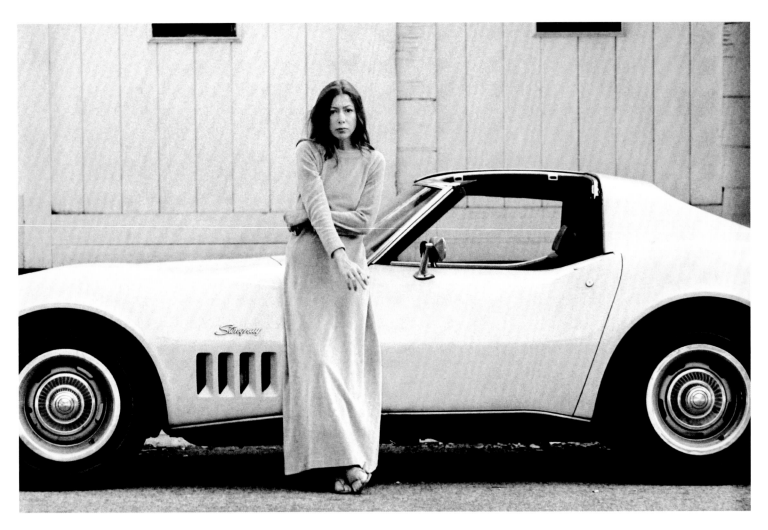

Julian Wasser, *Hollywood*,
1968
© the artist and courtesy
Danziger Gallery

Opposite:
Juergen Teller, Joan
Didion, for the Céline
Spring–Summer 2015
campaign, New York, 2014
Courtesy the artist

According to Hilton Als, an aspect of Didion's genius was "to make language out of the landscape she knew."

juxtaposition suggests. As an analogue, consider a Garry Winogrand photograph, taken in Beverly Hills, of a young woman in a miniskirt decorated with hearts. Is the faceless man beside her a threat, in his leather jacket and knee-high boots? A species of overlit dread pervades much of Didion's work of the 1960s, even more so the retrospective essays of the decade following. Another name for this feeling is *California.*

According to Als, an aspect of Didion's genius was "to make language out of the landscape she knew." There are photographs in the book and exhibition that stand somewhat literally for essays in which she draws on Californian history, fable, contemporary, or horror. In her 1970 essay about visiting the Hoover Dam, and again in "Holy Water" (1977), Didion conjures an arid land in which water is money, power, myth, and also metaphor for hope, movement, loss. A 1928 photograph of Mount Tamalpais by Alma Ruth Lavenson and Edward Weston's *Badwater, Death Valley* from 1938 summon the geocultural bedrock of Didion's early life and much of her work about the West. Also in the book and exhibition are snapshots of a heavily pregnant Sharon Tate in 1969, shortly before she was murdered. Mythic land, end-of-the-1960s nightmare: direct illustrations from these histories don't quite capture the peculiar, drifting abstraction that can shadow Didion's fidelity to fact.

Here, for instance, is a passage from *The White Album* on the mood in Los Angeles during the summer leading up to the Manson murders: "A demented and seductive vortical tension was building in the community. The jitters were setting in." What is the photographic correlative for the vortex, for the jitters? It's not to be found in Californian landscapes, austere or picturesque, or in the glassy midday version of street photography that LA makes possible. It's more visible, I think, in the streaked darkness of the book's 1943 Jack Delano photograph of the

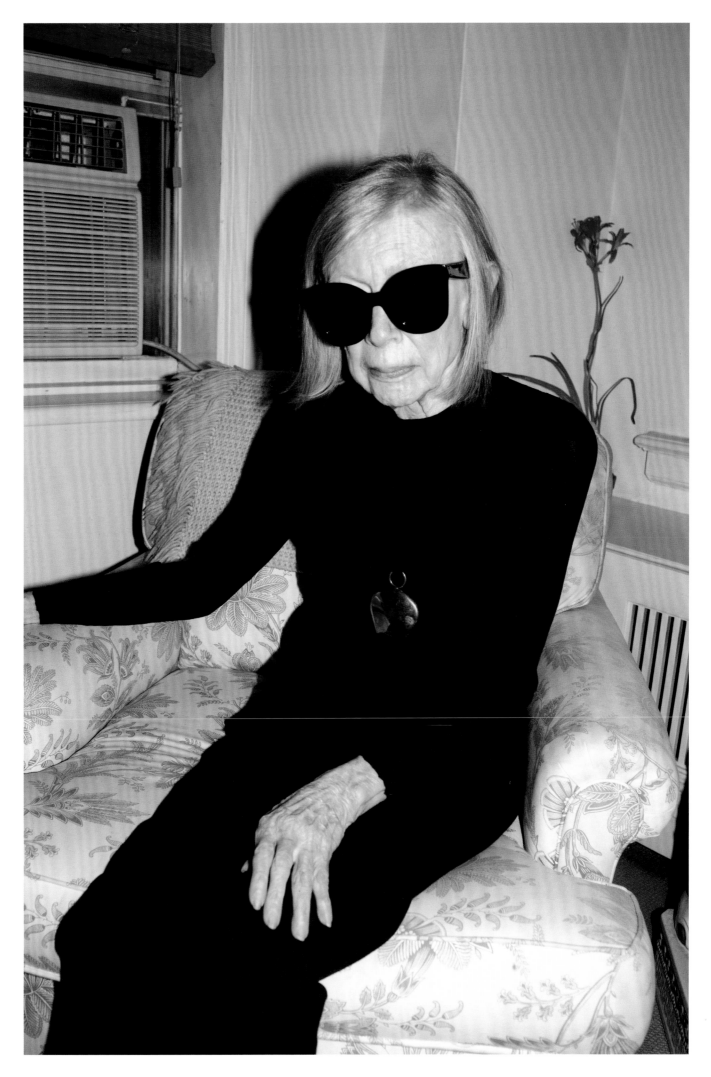

city's rail yard at night, or in the serial vacancies of Ed Ruscha's conceptual noir: blurred cars on Santa Monica Boulevard, repeated-with-a-difference gas stations, low-rise apartments, palm trees. The auction of items from Didion's estate reveals that she owned several of Ruscha's books from the 1960s and 1970s. In 2005, for the catalog of his contribution to the Venice Biennale, she wrote a short essay in which she describes the peculiar atmosphere of approaching the city from LAX: "Which streets they were did not matter. What did matter were the hard industrial angles, the gas stations and the strip malls and the two-story apartment buildings with the outdoor stairways and the covered walkways upstairs, the very stuff that said Los Angeles to me, all swimming in the lurid light that comes there in the western sky for a few hours before the sun drops below the horizon and the known world goes dark."

There's something inordinate in such passages, exceeding Didion's attachment to the concrete or, as she sometimes put it, her strict inability to think in the abstract. (As a student at Berkeley, she recalled, she tried hard to consider the Hegelian dialectic but was apt to be distracted by petals from a flowering pear tree outside her window.) The quality I'm trying to catch here is not exactly abstract or conceptual in ways we might speak of those things in modern or contemporary art. But it belongs to a region of the mind, perhaps of the world, that won't easily give itself up to word or image. An obscurity of scene, mood, or atmosphere that is maybe best captured, among the illustrations in *Joan Didion: What She Means*, by a Diane Arbus photograph, from 1960, of a New Jersey drive-in movie theater. Is that the sun or moon on screen, clouds scudding across? Points of light in the dark foreground, desires hidden in automobile interiors. (See also: the lowering sky, in three stills from *Stagecoach* [1939], behind John Wayne, whom the young Didion adored.)

In "Why I Write," a lecture delivered in 1975 and published the following year in the *New York Times*, Didion states, "The arrangement of the words matters, and the arrangement you want can be found in the picture in your mind. The picture dictates the arrangement." It's easy to imagine that she simply intends the affixing of a tracery of style to observed or recalled reality. In fact, it's not at all clear what Didion means by "the picture." Despite its precision, the prose is not a type of documentary, analogous to photography. (No more, of course, is documentary photography only documentary.) Instead, she writes to diagnose and to divine—like the greatest photographers, straight or conceptual, she is also searching for something that cannot be seen.

Brian Dillon is the author of *Affinities: On Art and Fascination* (2023) and is working on a book about Kate Bush's 1985 album, *Hounds of Love*.

Edward Weston, *Badwater, Death Valley*, 1938
© and courtesy Center for Creative Photography, University of Arizona

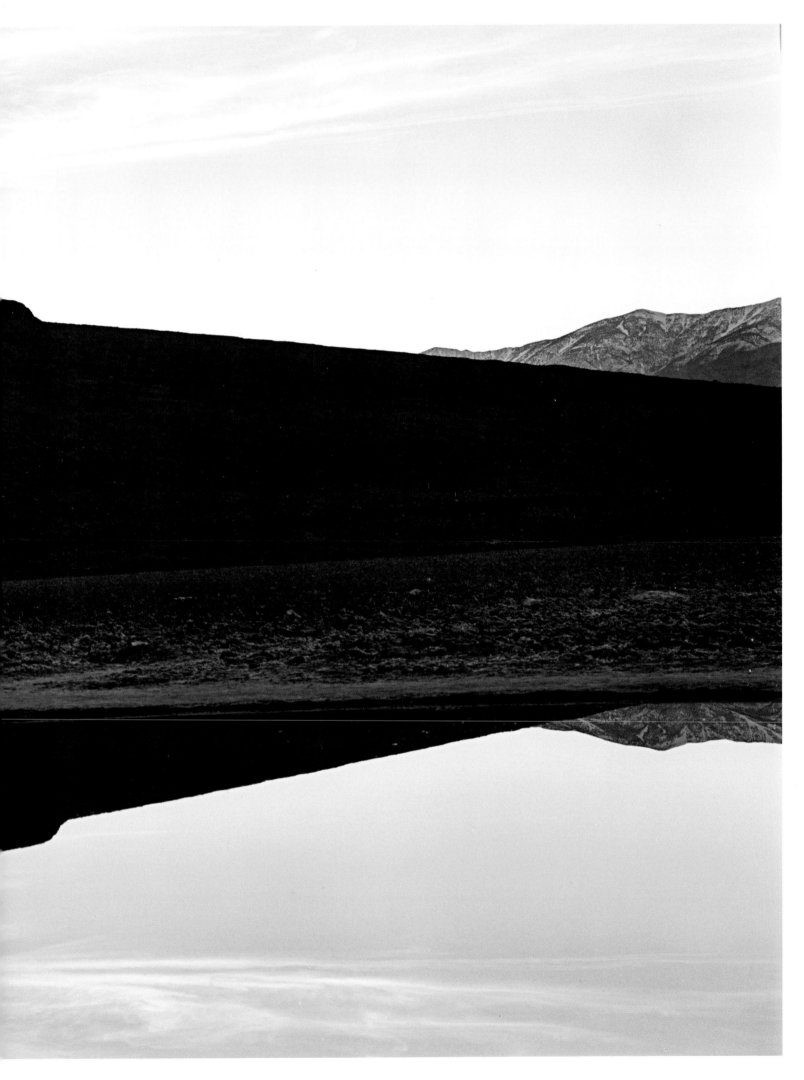

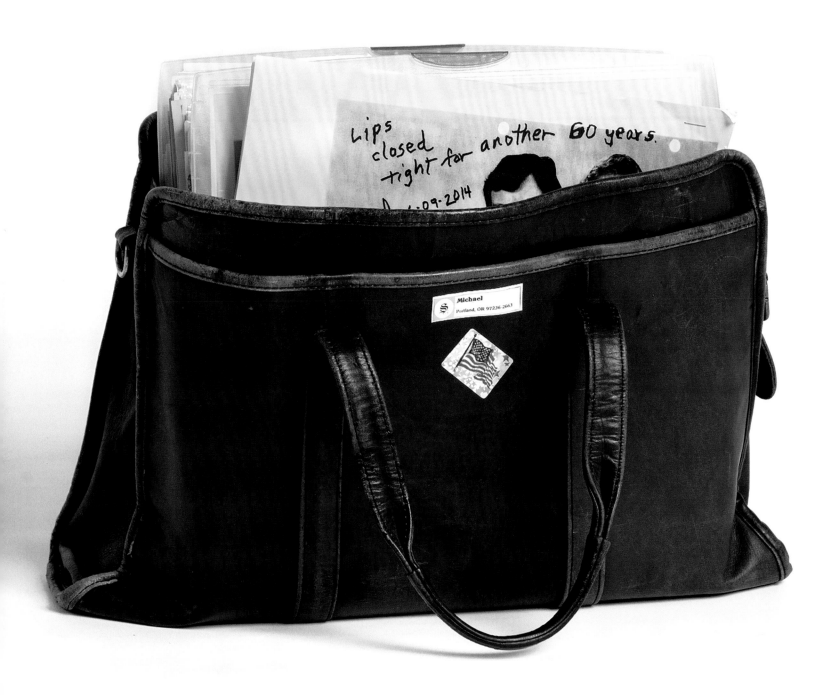

Bieke Depoorter

Conversations with Pictures

For the Belgian photographer, documentary is a listening exercise and a form of investigation, as she builds relationships with her subjects, blurring the lines between authorship, fiction, and truth.
Thessaly La Force

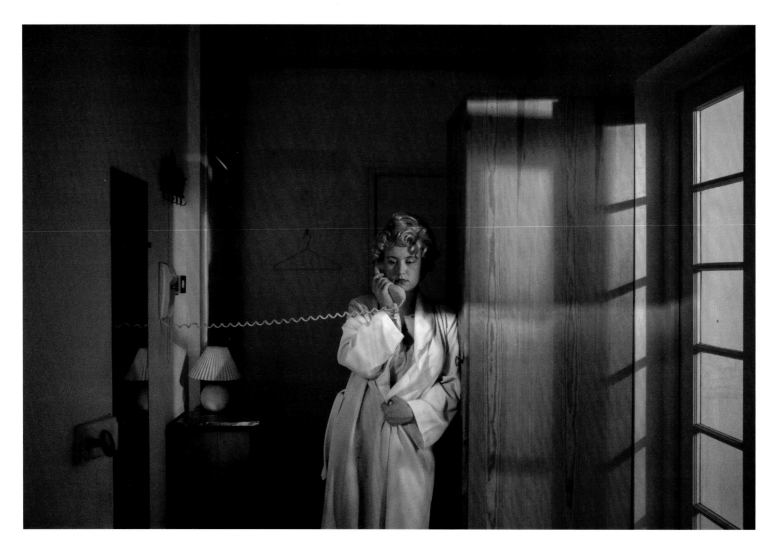

In fall 2022, the Belgian photographer Bieke Depoorter was in New York for a group show, *Close Enough: New Perspectives from 12 Women Photographers of Magnum*, at the International Center of Photography, where portions of her yearslong project *Agata* (2017–20) were on display. From there, she planned to travel to California and Oregon to continue her work on another ongoing project, begun in 2015, called *Michael*. Both are visual studies of a person Depoorter is interested in photographing—Agata Kay (her last name is a pseudonym) is a performer and former sex worker who Depoorter encountered in Paris in 2017; Michael is an elderly man whom Depoorter struck up an unlikely acquaintance with on the streets of Portland in 2015—but both are also about the complex and uncomfortable ways a photographer can become enmeshed in the life of her subject. "I don't really pick my projects," Depoorter tells me. "They happen to me. They become part of my life and that can become very overwhelming."

At thirty-six, Depoorter possesses a quiet confidence that makes it possible to understand how someone would be at ease with her when she's behind the camera. Ever since she began taking pictures, Depoorter has been preoccupied with the ethical questions surrounding the art. What is exploitative? What is purely in the self-interest of the photographer? "In school, I always felt very uncomfortable photographing someone on the street without their consent," she says. "I really love documentary-style photography, but I always had a feeling that I was stealing images of people. I want to have a relationship with the people I photograph. It can be a short relationship; it's not as though you need to build a friendship. I see making pictures as a conversation."

What this conversation looks like, and how long it will take, is entirely dependent on the dynamic between Depoorter and her subject. In the case of *Agata*, Depoorter was on assignment for Magnum Live Lab in Paris, a residency hosted by the Magnum Photos agency, and struggling to regain her footing as an artist. She had just broken up with a boyfriend and was having a hard time. After being invited to a strip club by a doorman she had become friendly with, Depoorter met Kay, who was working that night. Their encounter began an involved and complicated relationship. The two would eventually travel together, as well as engage in an honest and philosophical epistolary exchange about the pictures they were generating, with Kay even contributing her own ideas and opinions to Depoorter's exhibitions. In 2021, Depoorter published a book about Kay that contains not only her photographs but both of their observations of how their relationship has changed by the force of Depoorter's lens and how it presents Kay to the world.

In *Agata Kay, Paris, France, November 2, 2017*, a striking image from the day after their first meeting, Kay stands in front of a fuchsia-pink wall, in a loose bodysuit of the same color. Her hands rest on the bottom hem, along the pubic line, a gesture that suggests exposure, as if she might remove the article of clothing. But her pose is not one of seduction—the expression on her face is at once confronting and vulnerable. Depoorter seems to be asking: Who really is Agata Kay? Kay the sex worker is different from Kay the performer, who is different from Kay the person, who is different from the Kay that Depoorter reveals in her work. "The picture can never be true," writes Kay at one point. "Neither is it a lie. It is just a carefully selected excerpt of what is a point of view." That *Agata* is mutable—never fixed with one image, one show, one voice, or even one book—appears to be what Depoorter finds so exhilarating and challenging about photography. The impossibility of capturing the true Kay through one picture is precisely the point.

❋

Depoorter was born in 1986 in the town of Kortrijk, Belgium, the second of three children, to an electrician and an elementary school teacher. Growing up, she was not exposed to much art or photography, but as an adolescent she came into possession of a digital camera. The first photographs she took were of her pet guinea pigs alongside her younger brother's toys. When Depoorter was eighteen, she enrolled in the Royal Academy of Fine Arts, in Ghent. Her mother had made her take an aptitude test to help determine what kind of profession she might be suitable for as an adult; it had suggested educational sciences, which terrified Depoorter enough for her to stake a claim in the arts: "I thought, Okay, I need to take my life in my hands because otherwise I will be stuck forever."

At the Royal Academy, where Depoorter received both her bachelor's and master's degrees, she felt comfortable among the artistic and creative milieu of the program. Her 2008–9 thesis project, *Ou Menya*—which would also become her first published work—was the product of three month-long trips through Russia along the Trans-Siberian Railroad. Due to the region's few hotels, Depoorter's own lack of funds, and her inability to speak the language, she approached strangers in the towns with a note in Russian that read: "I'm looking for a place to spend the night. Do you know someone who might have a bed or a sofa? I don't need anything special and have a sleeping bag with me. I don't want to stay in a hotel because I have little money and I want to see how people live in Russia. May I sleep at your home? Thank you for your help!" This request gave her the opening she needed as a photographer. In the privacy of people's homes, Depoorter was able to witness deeply intimate moments— teenage girls performing rhythmic gymnastics in their underwear; a young mother calmly smoking a cigarette next to her two rambunctious children—that quietly reveal not just the poverty

Page 40:
Briefcase, May 2015,
from the series *Michael*

This page:
*Agata Kay, Paris, France,
November 2, 2017*;
opposite: *Agata Kay,
Neuilly-Plaisance, France,
September 4, 2018.*
Both photographs from
the series *Agata*

"I don't really pick my projects," Depoorter tells me. "They happen to me. They become part of my life."

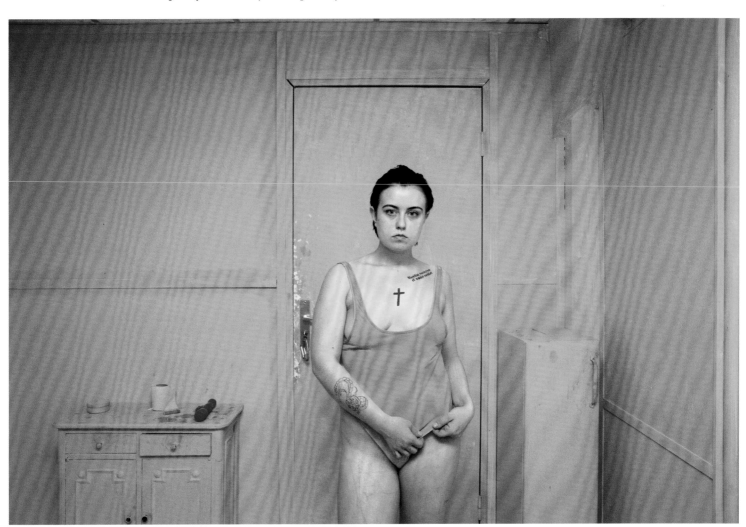

and starkness of Siberia but the warmth and generosity, the despair and resignation of the people living there. For the first time, Depoorter was comfortable with her role as photographer. "Despite the language barrier, I suddenly had a relationship with the people I was photographing, which I had missed before," she explains.

Her student years, Depoorter felt, had been more about her trying to be someone she wasn't. "I might have seen a scene on the street, and I'd be very focused on finding the perfect composition. I would have created the image in my mind, and I would stay out on the street for an hour or more just to make this image. But I always had the feeling when I got back home and looked at the photograph that it lacked something," she says.

Ou Menya established Depoorter in the photography world. In 2012, at the age of twenty-five, she was asked to join Magnum. Subsequent works of hers, such as *I Am About to Call It a Day* (2010–14) and *As It May Be* (2011–17), follow a similar vein: in both, Depoorter set herself in a foreign country (the United States and Egypt, respectively) and found ways to stay in the homes of complete strangers, photographing the people and landscapes she came in contact with, often over the course of several years. With *As It May Be*, Depoorter evolved the concept. She had become increasingly uncomfortable with her own power as the photographer, and when she returned to Egypt one last time—it had become more and more difficult for her to travel there after the Arab Spring—she brought a mock-up of the book she had been planning to publish from these trips but then put aside. "I had started to feel like an outsider," Depoorter recalls. "Did I make a book from a Western point of view? The photographs I took were not an accurate reflection of Egyptian life. They didn't show much of the revolution and the complexity of the country. Wealthy people, for example, didn't welcome me into their homes, and many people refused to be photographed." It was there, with a mock-up she felt she had no right to publish, that Depoorter decided to ask Egyptians to write their thoughts on top of her images. Her work became a medium for exchange. "The book is really beautiful and wonderful," reads one person's comment, "but there are not enough images that show happiness." Another: "I think you should start the book all over

This spread, opposite:
*Al-Mahalla al-Kubra,
Al-Gharbiya*, November
2015, from the series *As It
May Be*; this page: English
translation of the Arabic
text in the image opposite

You can stay with me, no problem, a day, a week, a month. But taking pictures: no.

Sometimes all the borders—customs, traditions, doctrines—can make you lose confidence in yourself. You have to trust yourself first before you can trust others.

My name is Nora and I come from a middle-class family. I think my parents would never allow a stranger to come stay in our house for a day, because of issues with privacy and fear of strangers and crime. The fear is due to all the problems we read about on social media, fear that these stories might happen to us. I wouldn't allow you to take a picture of me because I would consider that a violation of my privacy. And because I'm not used to dealing with strangers.

I am one of those people who wouldn't want to be photographed in my house while relaxing.

I sit like this at home every day.

There are a lot of people out there who think this way because of the current situation.

Mama says spend the night with us, or with Karima our neighbor,

because her bathroom is better.

Who is Regeni the Italian?

I agree with these ideas.

Haven't you heard about Regeni, the Italian?

People here are programmed to think that a foreigner with a camera is a spy.

The problem is not privacy. The problem is our fear of how people will judge us.

But that's actually true.

Why are people afraid of you?

If they knew that this book would be published in Egypt, they would not agree to being photographed.

Advice from a father to you: Don't trust anyone, because that's just blind trust. But treat people with good intentions, until something proves otherwise.

They tortured him as if he was Egyptian (the mother of Regeni said). That's very painful for us, as Egyptians.

The picture was taken when she was in a bad state of mind, a sad mood.

المحلة الكبرى، الغربية، نوفمبر ٢٠١٥

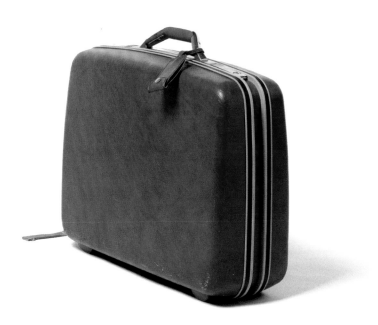

Depoorter instinctively understood that Michael felt comfortable making sense of reality through images and writing, much in the way she did as an artist.

again. Take pictures that express something and are about Egyptian civilization." For Depoorter, allowing her pictures to be critiqued, commented on, and even defaced by the pen was a solution she hadn't realized existed before. "Photography alone felt so limiting, and the use of text opened a whole new conversation," she says. It was a liberating discovery, one that would push her art to new levels.

✳

In May 2015, Depoorter was in Portland, Oregon for another Magnum project when she met Michael. He had bipolar disorder; he told her that he had no phone or internet and was fond of walking by himself for hours a day. Michael agreed to let Depoorter photograph him, and they ended up spending the afternoon together. During her remaining days there, Depoorter visited Michael two more times. He invited her into his apartment on each occasion, and they looked at his belongings, mainly pictures he had saved from his life, magazine clippings, and books. "I got most of those pictures out of magazines," he told her in a recording she made at the time. "But I tried to put them in ways that would make sense out of them. . . . They aren't just hodgepodge pictures that don't go together. They go together." Depoorter instinctively understood that Michael felt comfortable making sense of reality through images and writing, much in the way she did as an artist. "His collages were created by someone with a keen sensitivity for peculiar beauty," Depoorter observed. In one photograph by Depoorter, Michael is in his apartment. His walls are covered in a seemingly haphazard array of images, some imperfectly cropped from magazines, others framed, crowded together along whatever space he finds. Yet Depoorter's empathy is powerfully present in the image. The disarray that betrays Michael's unwillingness or perhaps inability to conform to societal notions of presentation within the home doesn't appear chaotic. If no one else was listening to Michael, Depoorter was.

Depoorter returned home to Ghent, Belgium, and continued on with her life and her work. She sent Michael postcards and a letter from her travels, but that was extent of their communication. Shortly after their time together, Michael sent her a small suitcase filled with more pictures, clippings, and other ephemera (during her visit with him, he gave her a briefcase and another suitcase that she had photographed and returned). But time passed. Depoorter had been busy on the road. A year later, she finally went through Michael's briefcase, where she found a letter from Michael asking for her help. Concerned by his subsequent silence, Depoorter decided to return to Portland in the spring of 2018 to speak to him face-to-face. But Michael had been evicted from his apartment and no one had seen him since. So Depoorter began to search for Michael herself, documenting what she discovered, including his former apartments and other places where he had resided throughout his life. She visited and photographed scenic destinations he had included in his scrapbooks, such as Mount Hood and Lost Lake. She spoke to people who had gone to school with him. She even attended a graduation at his former high school. "I wanted to understand the links he made and understand his past. I didn't want to judge him; I just wanted to understand his life," Depoorter says.

She has shown portions of *Michael* and has made several compelling short films that include her audio interviews with Michael and the people who knew him, but as of yet the project is incomplete. This work is less a dialogue between subject and author and more a detective story, one in which Depoorter is fully allowing herself to try to see how close she can get to Michael's experiences and feelings, piecing together his life from whatever she can find and repeating his movements in a gesture toward proximity. What began as a kind of listening exercise, an attempt to hear Michael and view him uncritically, is now something else. It is as though

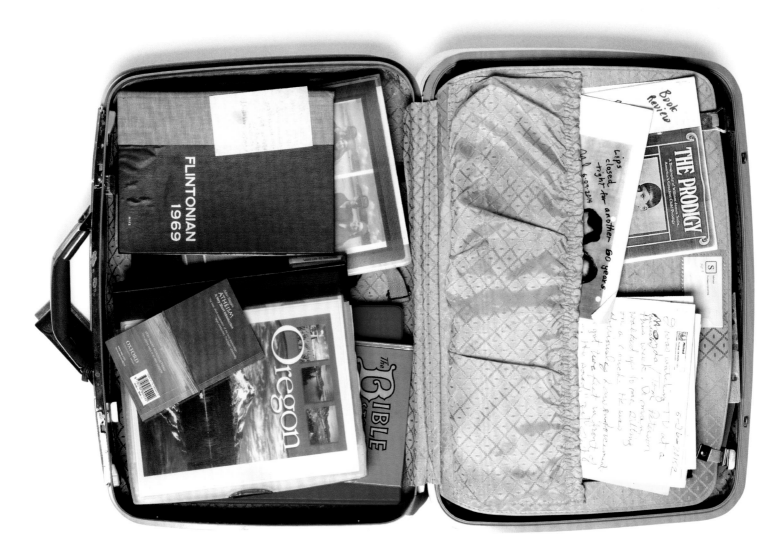

Depoorter is no longer trying to find Michael, who perhaps doesn't even want to be found. The piece has become, in many ways, a manifestation of Depoorter's own obsession. "I felt lost," she says in one of the films. "I didn't remember what I was looking for."

At one point, while parking her car close to one of Michael's childhood homes near Yosemite National Park, she sees an object flash briefly in the night sky. Is it a UFO? Something else passing by? Her images of it are blurry, but something uncanny-looking is there. She has a recording of her speaking to a man fishing nearby. The two are in shock, even jittery with excitement at what they have just witnessed. With *Michael*, Depoorter allows herself to be drawn into the abnormal. The result is peculiar but also isolating and unusual. Depoorter seems to retreat to somewhere that is about neither Michael nor herself, lost to the mystic beauty of the West Coast's natural landscape and its vast wilderness.

It will be interesting to see what Depoorter—still very much in the middle of her career—will do next. Her preoccupation with narrative and storytelling, particularly the suspense that drives *Michael*, reminds me of films by the Austrian director Michael Haneke and the work of the French artist Sophie Calle. Depoorter cites the influence of Magnum photographers such as Jim Goldberg and Susan Meiselas, both artists who have helped canonize the act of collaboration within the form. She admits that her fascination with documenting events in her life can be overwhelming—for a while, she compulsively recorded her own banal or private moments. "If something happens, and if you don't have a picture or a recording, did it happen?" Depoorter asks. "Maybe people don't believe you, but at the same time, perhaps a picture is not everything. I don't believe pictures either." Depoorter's work confronts the established authority of the author of the photograph. She pushes against the boundaries of what is

seen as the truth. By seeking a dialogue with her subjects, she invites questioning. Where is the reality? Can there be an objective point of view?

Depoorter describes the camera as an incredibly powerful tool. It can serve as a shield, as a form of memory, as a way into an inhospitable scenario or situation. It also offers her perspective on what can feel too close. "I pick up my camera, and I start to film and to photograph. It helps me observe myself," she says. "You become an actor in your own life, where you can deal with certain feelings. You can distance yourself from emotions when you start to make something." What the end result will look like is always uncertain. But Depoorter will capture it, no matter what.

Thessaly La Force is a writer based in New York.

Top:
Michael outside his home,
Portland, Oregon, May
2015; bottom: Michael
carrying a suitcase to
Depoorter's car, Portland,
Oregon, May 2015

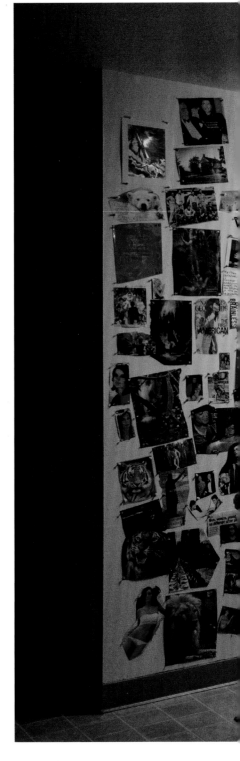

Michael at his home,
Portland, Oregon,
May 2015

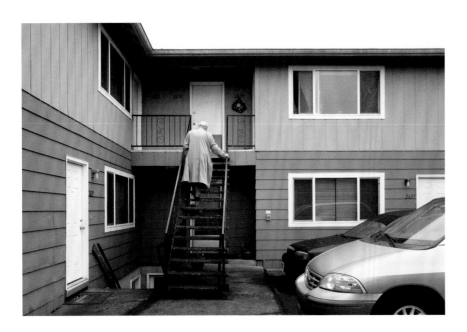

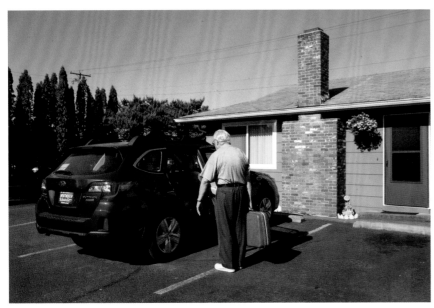

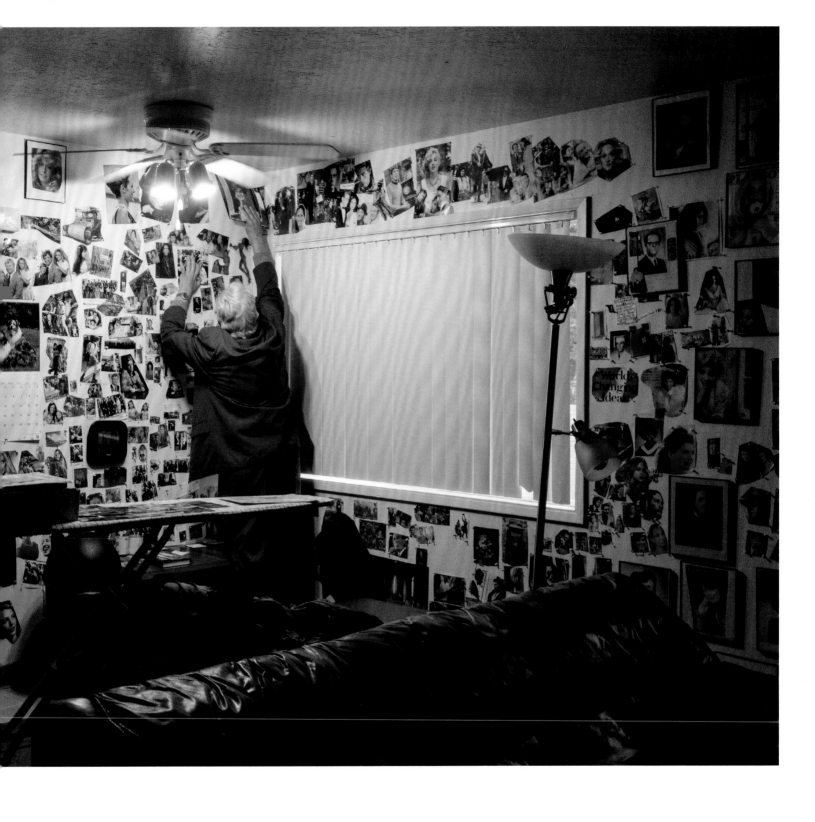

This spread:
Pages from a self-made
scrapbook Michael gave
Depoorter, May 2015

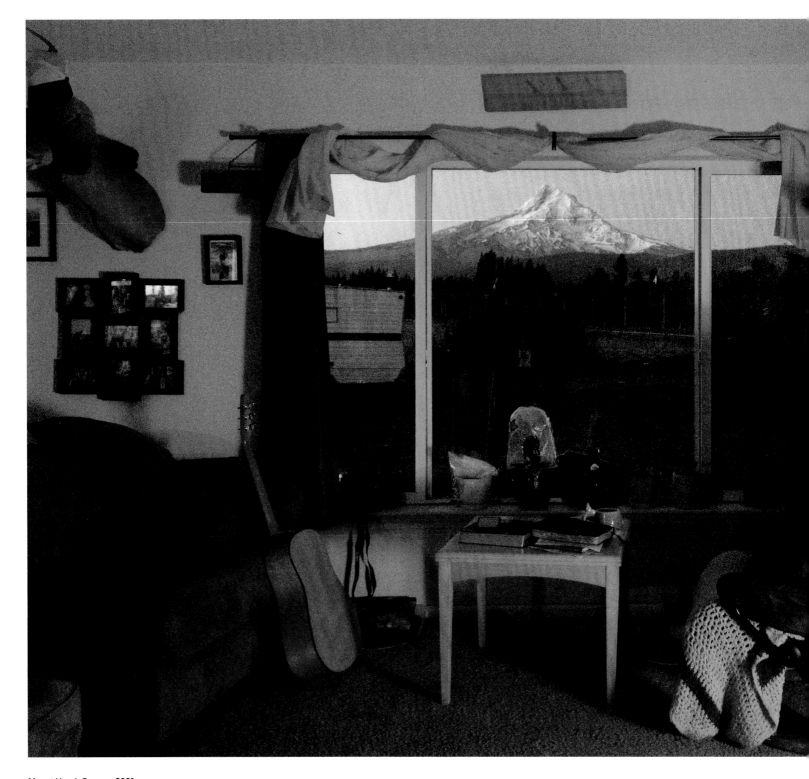

Mount Hood, Oregon, 2021

Top:
Mount Hood, Oregon,
2021; bottom: Depoorter
observed a strange
phenomenon in the sky
while parked near one
of Michael's childhood
homes. Michael had once
written of being the owner
of the universe. October 7,
2018. 9:25:06–9:34:05pm,
California. Page 48–this
spread: All photographs
from the series *Michael*
Courtesy the artist/Magnum

Nick Waplington

From Nottingham living rooms to New York dance floors and Los Angeles's surf scene, the British photographer has created records of subcultures that brim with life.
Alistair O'Neill

Histories from Below

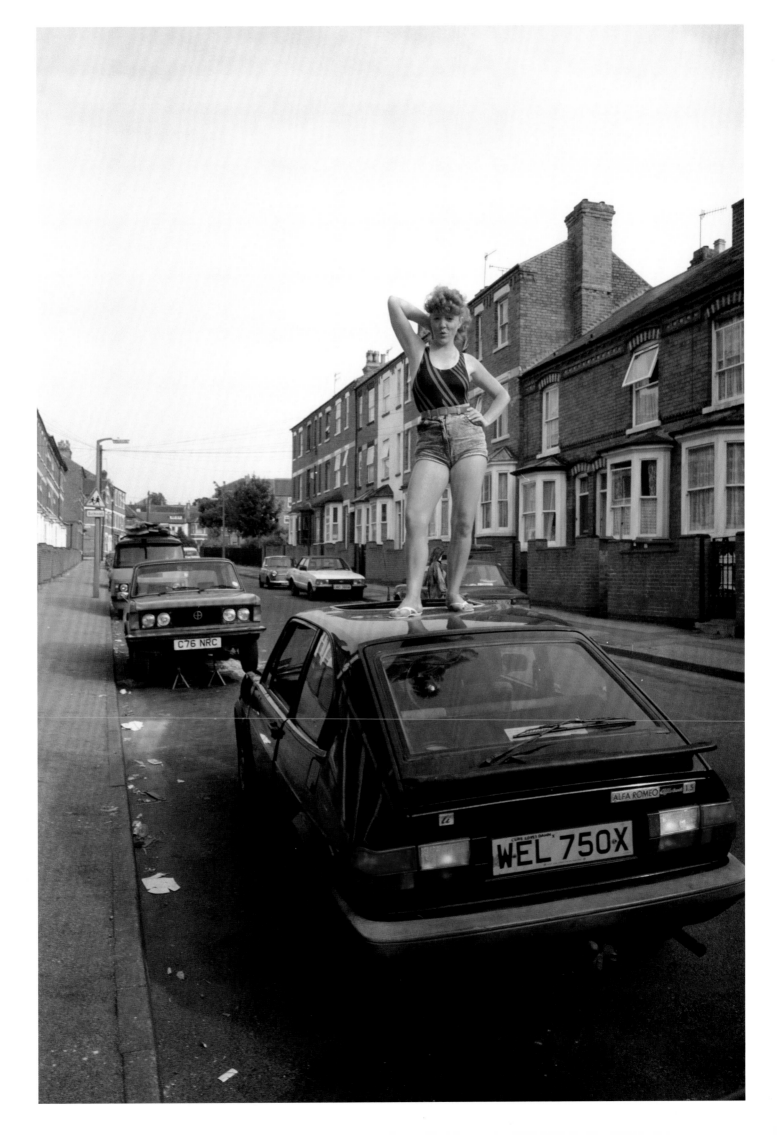

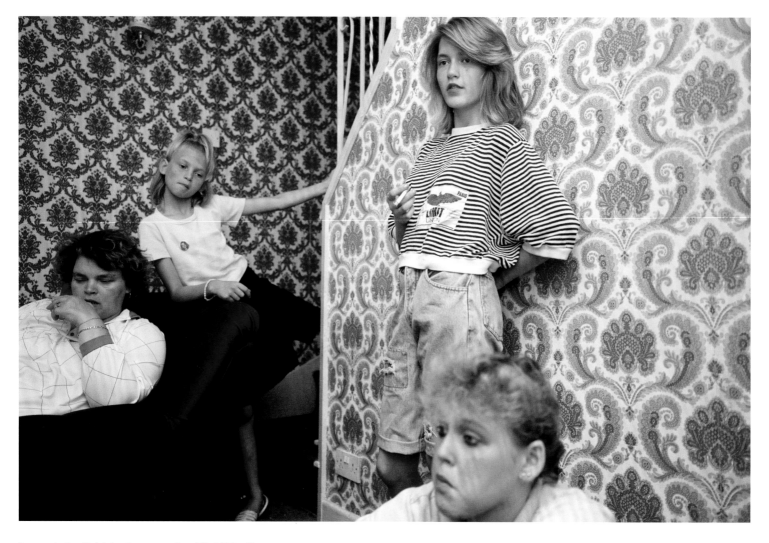

In 1996, the British photographer Nick Waplington wrote out a handwritten slogan that states: "EVERYTHING THAT HAS HAPPENED BEFORE IS HAPPENING NOW." Published in *Safety in Numbers* (1997), his account of a year on the road in New York, Los Angeles, Tokyo, Johannesburg, and London, it's a line that might also describe Waplington's methods, as he often makes photographic series without a sense of his final intention. "I keep work when I am not really sure why I am making it at the time. I build up an archive to use in the future, and then I'll come back to it," Waplington says. "For example, I took a lot of pictures from the age of fourteen to twenty that I only started publishing in 2014."

Waplington is committed to the idea of entering communities in order to understand them and, in turn, himself. When I visited his East London studio last summer, he told me, "I have an ability to seek out weird, subcultural groups that I find interesting, and I kind of submerge myself. It becomes my world, and I make work about it. Then, I present the work to the world."

With a career spanning more than thirty years, Waplington, who was born in 1965, has dedicated himself to extended periods of fieldwork in the United Kingdom, the United States, Europe, and Japan. He has produced photobooks that deal with subjects as diverse as the inhabitants of a housing estate in the East Midlands of Britain, a beach riot in Southern California, Jewish settlers in the West Bank, river swimmers in East London, and club kids in New York. His is a wandering existence, connected to the level of the everyday in the community in which he is immersed, but not to a place he can necessarily call home.

It's a way of working that the social sciences identify as participant observation. But Waplington's photographs are not academic; they lack critical distance from their subjects, and their objectivity is not as detached as it could be. His time-consuming,

personal involvement enables a pictorial command of how people function in such groups: his pictures hum as scenes of life.

The writer Joan Didion's description (in 1979's *The White Album*) of how she saw her life at the end of the 1960s in Los Angeles is evocative of what Waplington's photography looks like: "I was meant to know the plot, but all I knew was what I saw: flash pictures in variable sequence, images with no 'meaning' beyond their temporary arrangement, not a movie but a cutting-room experience." Waplington takes a subjective viewpoint, like Didion's, and turns it into an image the viewer can recognize through visual cues. In sequence his photographs might look like a set of snapshots, yet the flashes and fragments amass until meaning is strung across them. His work confirms that photography is no longer about the nonfictional single image, but neither is his work about the staged moment.

Waplington currently lives in New York and London. The pandemic's ban on travel and social interaction arrested his embedded style of photography, but he made use of the time it granted him by taking stock of his archive in preparation for a survey publication, *Comprehensive* (to be published this fall). "I've had a trajectory where I make work all the time, and I don't exhibit very much," he says. "All I've done for the last thirty-five to forty years is make work, and then make books, and, very occasionally, do a show. This means that the amount of images is kind of crazy. Rather than use a bit of everything, what I am trying to do in *Comprehensive* is illustrate between five and eight projects in a bit more depth. When you open the book, you'll see a lot of pictures that you've never seen before."

This approach provides a refreshing opportunity to reconsider previously published series, destabilizing the narrative threaded through the sequencing of images in previous photobooks. What Waplington proposes with this method is the showing of a new hand by reshuffling and adding to the deck. For example, *Living Room*

(Aperture, 1991), his first publication, has fifty-nine plates, but they are drawn from five years' worth of photographs. So in *Comprehensive*, the tightly edited, linear narrative of the original photobook will be exchanged for a more circuitous route, offering fresh intersections and insights.

This strategy also makes the work engage with the concerns of the here and now. In discussing with Waplington which portfolios will appear in *Comprehensive*, it becomes apparent that the historical trajectory behind the production of the bodies of images weaves them together in ways that aren't pictorially evident. The book not only reveals Waplington as a prolific image maker, focused on more than one project at any one time, but shows how he networked across distinct creative cultures in Nottingham, London, and New York from the mid-1980s to the mid-1990s.

Living Room deals with life in the Broxtowe housing estate in Aspley, Nottingham, a predominantly working-class development in which Waplington's grandfather lived from the time it was built in the 1930s. Waplington's upbringing, in Surrey, was markedly different; his father had gone to university and was a nuclear scientist. Waplington started to take photographs, at age fourteen, of anti-apartheid marches and his friends skateboarding or partying; by the age of eighteen, he had become drawn to documenting life around his grandfather's house, and he would eventually apply for a degree in photography at Trent Polytechnic, enabling him to live and make work in Nottingham. It was during this formative time that Waplington honed his signature style, described in jest by the photographer himself as "that kind of Nick Waplington, 6-by-9 Fuji with the big flash gun of bounced flash, where things are happening in the corner, and the middle's kind of empty, or things are cut off."

Living Room is ostensibly about domestic life, but, as the pictures weave and sway from one house into another in fully

Waplington is committed to the idea of entering communities in order to understand them and, in turn, himself.

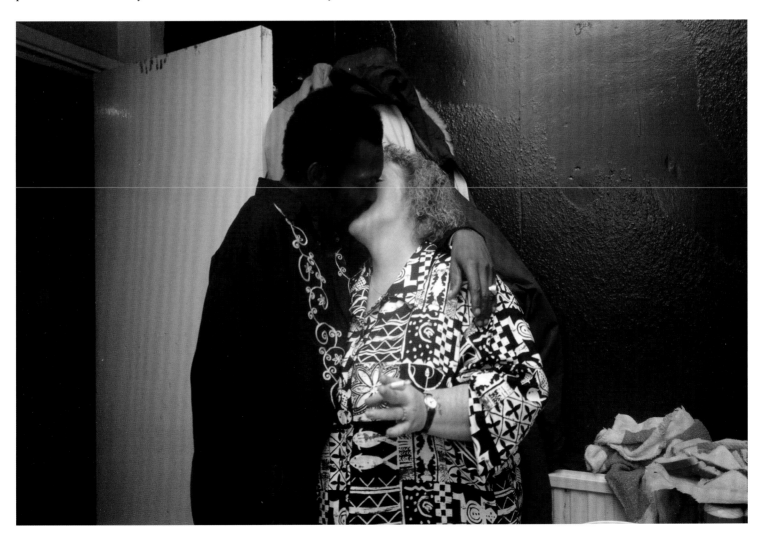

saturated color, there is no clear-cut sense of where one family ends and the other begins. Babies gurgle, fists fly, ice creams are bought, and humanity rolls on. "I really enjoyed being around those families, and the kind of looseness and fun and camaraderie that was going on in the estate. The ridiculous things that we would get up to were very different from the extremely rigid world of the Surrey stockbroker belt that I had grown up in, where my father, having come from that, was very keen that it was forgotten."

In 1988, at an interview for a place in the MA Photography program at the Royal College of Art, Waplington learned that Richard Avedon would be visiting the following spring to accept an honorary doctorate—and would give a master class. Waplington asked if he could attend, even though he would not yet have enrolled in the course; afterward Avedon raved about his photographs. When Waplington was in Connecticut in the summer of 1989, a few months before starting his MA, a note from Avedon arrived back home for him, saying, "I really was impressed, moved by the work you brought to my class." Avedon asked about acquiring a set of prints. Soon after, Waplington was hanging out in Avedon's New York studio.

Having recognized Waplington's talents, Avedon primed him to follow in his footsteps and become a commercial photographer. He introduced Waplington to the fashion designer Isaac Mizrahi, for whom he took photographs backstage and pictures of fittings from the late '80s to 1994, at the rate of $250 per day. At night Waplington was out in clubs, taking photographs at the Sound Factory, Limelight, Save the Robots, and various after-hours parties. "Mizrahi paid for the film and processing for those pictures, not that he knew it at the time," Waplington says. "It was very nice of him that he never questioned it."

It's hard to see a relationship between the two bodies of images, or to correlate how the days might have connected to the nights:

Nan Goldin was the first to tell Waplington that he was looking for the family he never had.

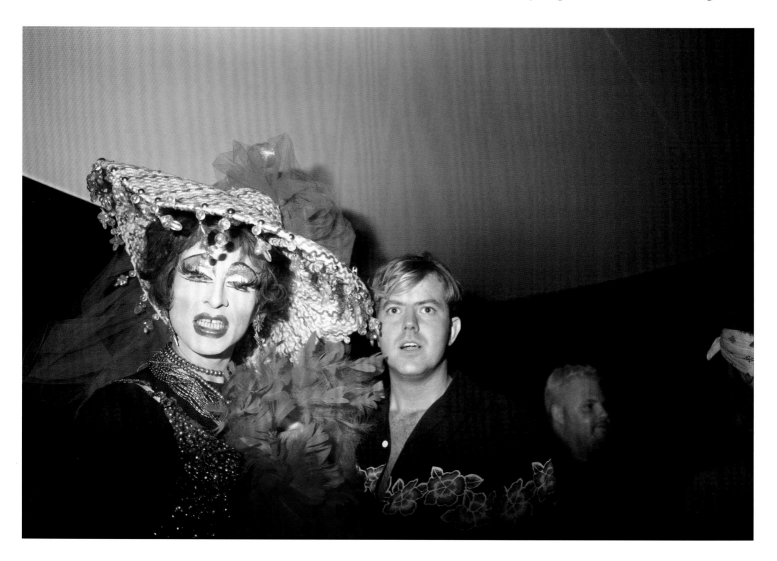

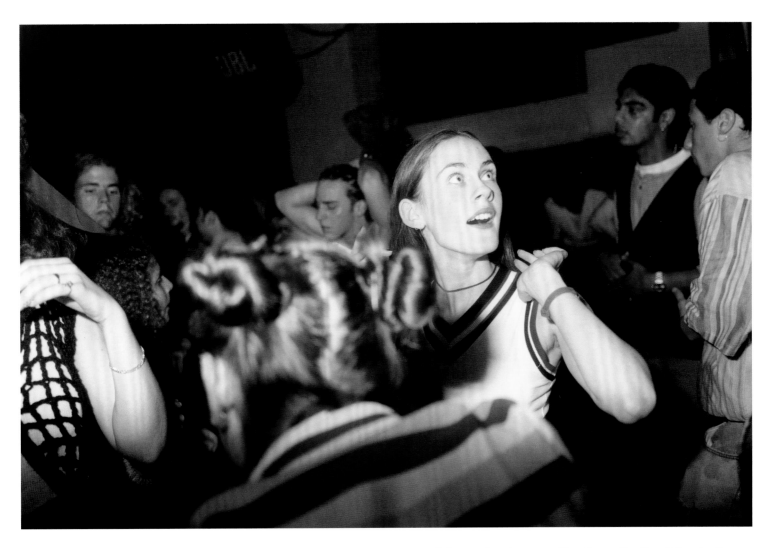

one looks like the last days of Versailles (before grunge hits), the other, the start of *Fellini Satyricon* (but with everyone in Lycra). Waplington says he always wanted to make art, and the experience only underscored that he had no interest in commercial photography. "What I wanted was to just make projects the way I wanted to do them," he says. "I came back to London and got a studio space on Brick Lane, with the Chapman Brothers and Sam Taylor-Wood. Even though there wasn't the money in it, there was an excitement." Soon, the print room at the Photographers' Gallery, London, was selling his pictures for £150 each; a small exhibition followed, and word spread quickly. In 1990, *Living Room* won an Eastman Kodak Award.

Waplington's work might best be served not by the ideas of social documentary photography—as a means of raising awareness or a tool for social change—but by the idea of "history from below." Developed by the British historian E. P. Thompson and typified in his book *The Making of the English Working Class* (1963), history from below rejects the focus on "the great and the good" of traditional political history in favor of the study of ordinary people and everyday life. Waplington's photography honors this recalibration's acknowledgment of class but destabilizes powers of division and exclusion by inverting the social hierarchy. Waplington's own needs align with this viewpoint. At the time that *Living Room* was being turned into an Aperture publication in New York, in the early '90s, Waplington was meeting photographers, including Sally Mann and Nan Goldin, who were bringing new meanings to the concept of belonging, in both nuclear and nontraditional families. Goldin was the first to tell Waplington that, maybe, he was looking for the family he never had.

The remarkable and unique quality of Waplington's approach to taking photographs is his command not only of what is included within the frame but of what is missing. Ursula K. Le Guin calls what is left in and out in storytelling "crowding" and "leaping": "By crowding I mean also keeping the story full, always full of what's happening in it; keeping it moving, not slacking and wandering into irrelevancies; keeping it interconnected with itself, rich with echoes forward and backward. . . . But leaping is just as important. What you leap over is what you leave out. And what you leave out is infinitely more than what you leave in. There's got to be white space around the word, silence around the voice." Le Guin is addressing a writer employing words, but it is no great leap to observe how well these ideas apply to Waplington's craft, especially the sheer physicality of what he pushes and pulls with his eye.

"The excitement never ends," Waplington says. "There isn't a day when I don't wake up excited to be getting on with it again. As New Order sings, 'There is no end to this.' I love it."

Alistair O'Neill is a professor of fashion history and theory at Central Saint Martins, London.

Untitled, from the series
Surf Riot, 1996

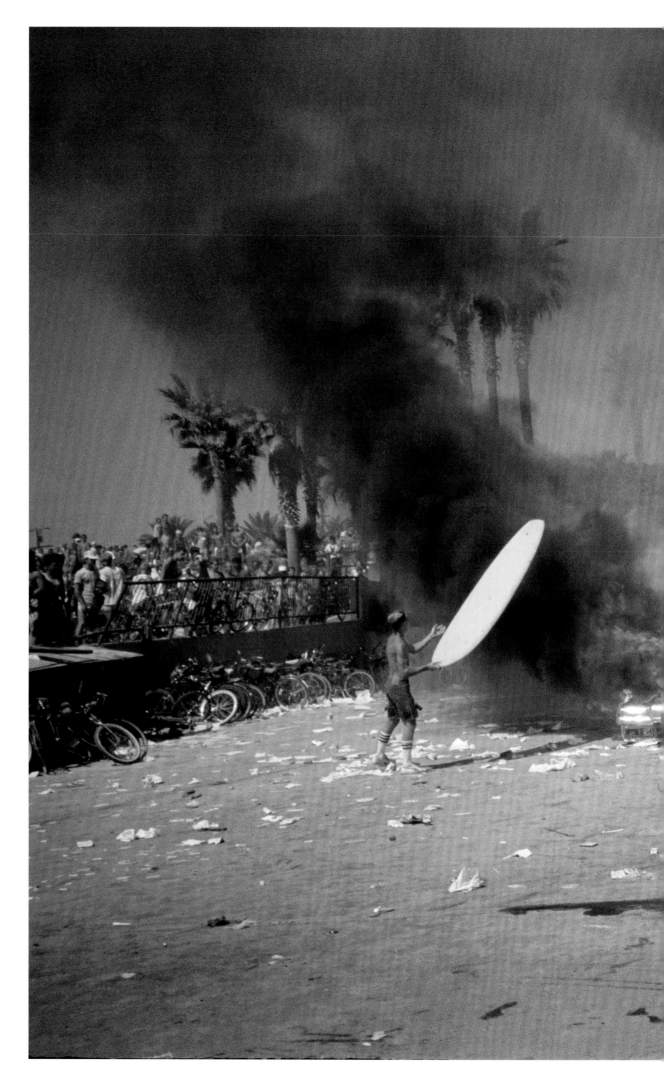

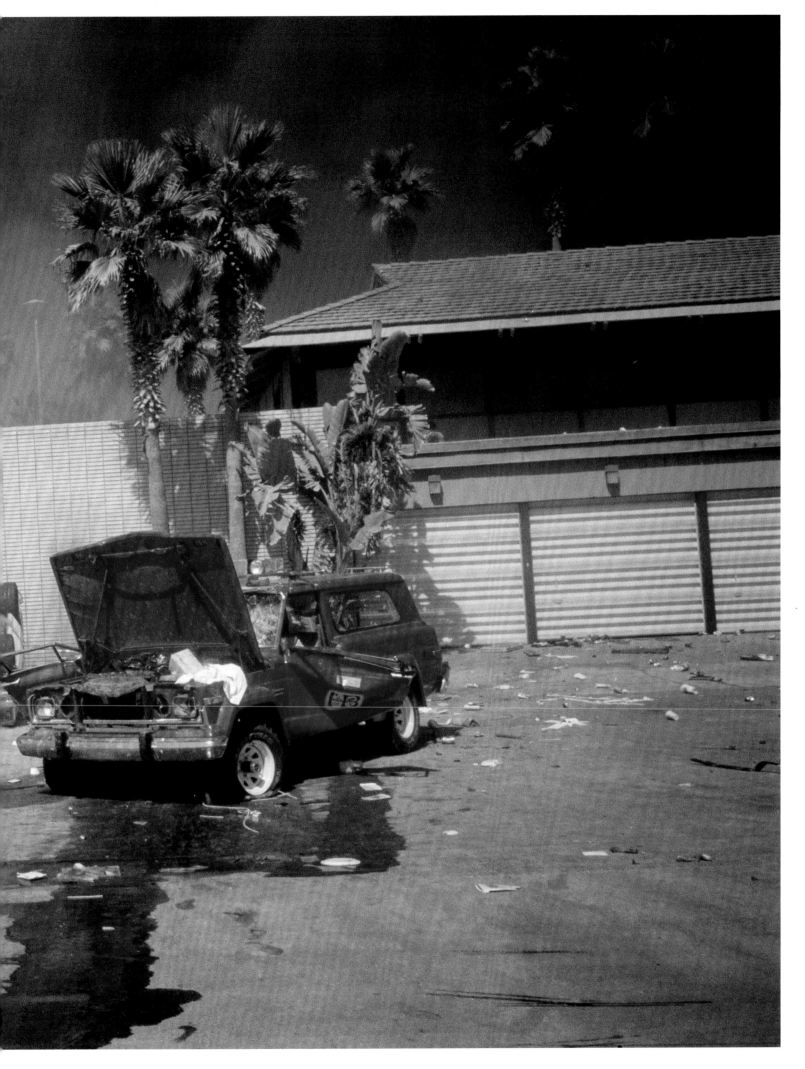

This spread:
Untitled, **from the series**
Safety in Numbers, **1996**
All photographs courtesy
the artist

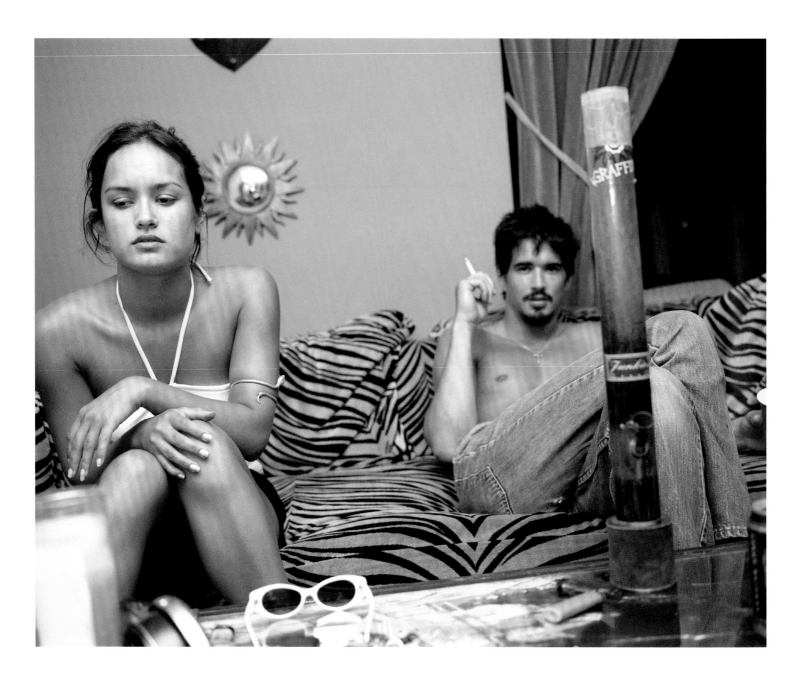

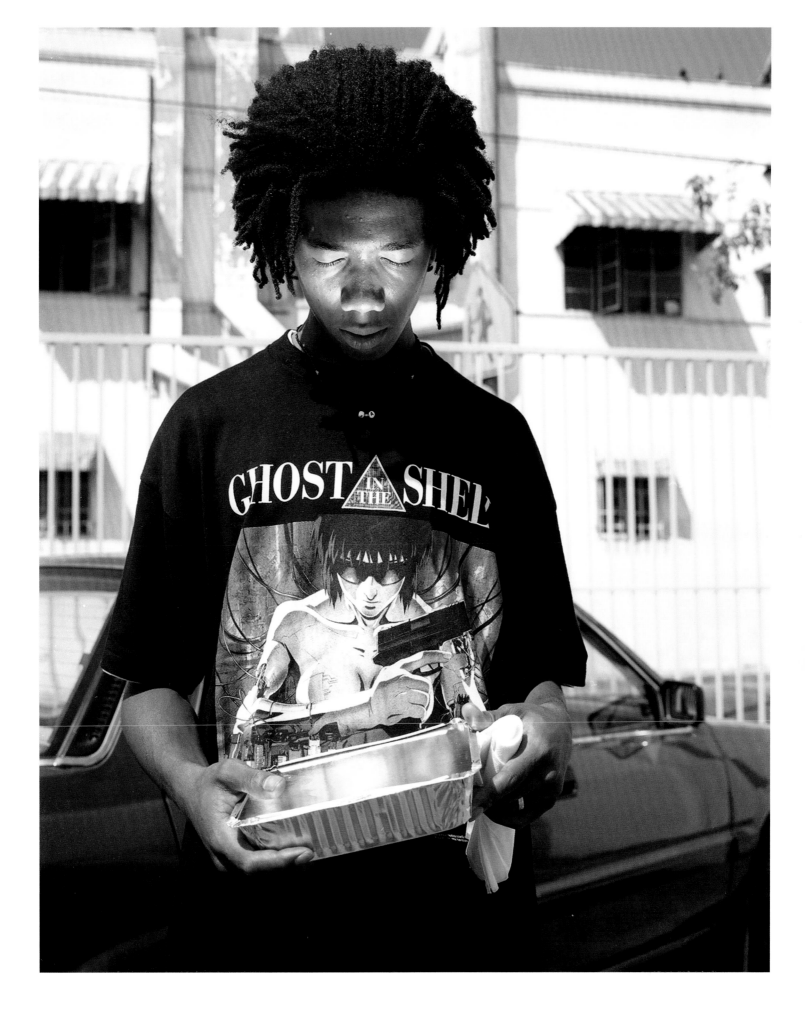

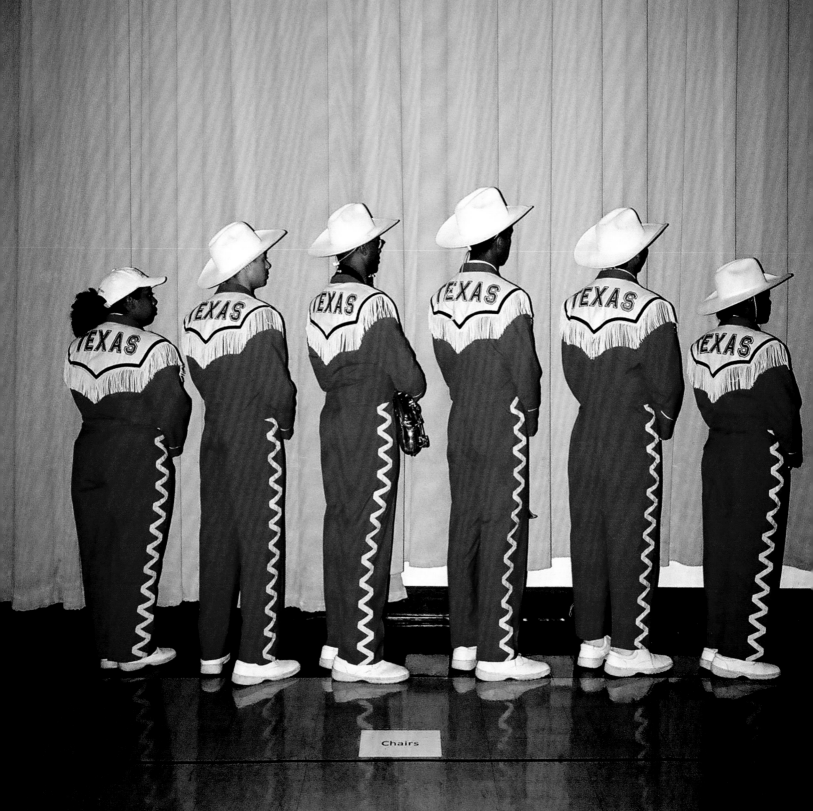

Adraint Bereal

A young photographer captures the agony and ecstasy of being a Black college student today.
Casey Gerald

The Black Yearbook

He spent much of 2021 on the road, taking more than a dozen flights, plus Amtraks, buses, and rental cars. He lived out of his suitcase for months, lugging along eight cameras—point-and-shoot, Polaroid, medium-format, "everything you could think of"—until the weight of all that gear wore him down. He shipped all but two home and kept going.

Bereal's mission was heavy enough: to meet at least one hundred Black college students across the country, capture their lives in images and words—preferably their own—and compile this material in *The Black Yearbook*, the second iteration of a project Bereal birthed in his senior year at the University of Texas at Austin. Returning from his travels, he faced another, more challenging task: meet a book deadline. He needed to pare down hundreds of hours of conversation, toss aside thousands of images, and cull from intimate human stories to produce a selection that his publisher, Penguin Random House, could present for mass consumption. The tightest spot of all is how to tell his and his peers' stories "without cutting away so much of ourselves," he told me recently.

Bereal's first photography endeavors occurred when he was a teenager in Waco, Texas, taking iPhone pictures of his mother's outfits before she went out. "It sounds so silly," he says, "but that was practice for me. I was learning about composition, learning how to have a conversation with not only the camera but the person in front of it as well." *The Black Yearbook*, in a sense, is an evolution of his earliest image making, equal parts archive and affirmation.

Photography wasn't much more than a pastime until one of his college professors suggested Bereal check out the work of Wolfgang Tillmans. "I went to the Austin Public Library," he remembers, "and there was one image in particular." Bereal later shared the image, *Forever Fortresses* (1997), which captures Tillmans holding the hand of his late partner, Jochen Klein, just hours before Klein died of AIDS-related pneumonia. "Seeing that image, photography as an art form, the power of images, finally clicked for me." Aside from their demonstration of technical mastery, Tillmans's photographs gave Bereal a portal through which to explore his own queerness, to see and understand himself.

The Black Yearbook project started from a similar desire: to help his classmates see themselves and celebrate one another on a campus where Black students comprise around 5 percent of the fifty-thousand-plus student body. The resulting crowdfunded 2020 publication resonated widely enough to spur him on his current journey to chronicle students' lives beyond Texas. "This is the first time anybody has ever just sat down, shut up, and listened to what they had to say," he states. He's found striking, if sobering, similarities across the country. "Many of these students haven't been taken care of on these campuses," he tells me. Some don't have proper housing, or a place to go back to for the holidays. Many students are struggling with mental health issues. Perhaps most obvious is the devastating effect of the pandemic. Bereal, who graduated in 2020—the first in his family to do so—participated in a virtual ceremony in lieu of a physical graduation. This is only one example of the ways in which he and his peers "had the rug pulled completely from underneath us." Yet, he's found much more than gloom. "Whether it be through a state of escapism or delusion, there are some students who are absolutely enjoying themselves," Bereal observes.

Images from homecoming at the University of Texas embody Bereal's approach and illuminate the lives that fill *The Black Yearbook*. There's one of the homecoming queen herself—flash galore, from the camera to her smile, her makeup highlights, her nails, her glittering tiara. Echoes of the fit pic, with the patina

The Black Yearbook project started from a desire to help Bereal's classmates see themselves and celebrate one another.

of a 1990s family photograph. "I'm having a really voyeuristic moment," Bereal says, "but I'm also participating in it, hanging out with my friends and just dancing with everyone."

In Bereal's practice, the photographer is comrade and chronicler, griot and visual artist. He walks the tightrope that stretches between the *I* and the *we*, engaging in the noble struggle to get the balance right and, most of all, to tell the truth, to capture the agony and ecstasy and in-between of what it is to be a Black college student today.

This kaleidoscopic hunger helps explain the variety in Bereal's images. Starting from a foundation of portraits, he seems as drawn to the disposable-camera-esque candid as he is to the high-gloss, highly staged ad. He is a poet of the party scene—some of Bereal's photographs call to mind the crowded, joyful abandon of Ernie Barnes's iconic 1976 painting *The Sugar Shack*—as well as the selfie, which he considers "an affirmation of self," recalling one of the positive things to come out of the COVID-19 lockdown. "When the pandemic happened, I spent a lot of time with myself. And it forced me to look in the mirror and say, 'All right, this is who I am. I don't always feel good. I don't always feel pretty. I don't always feel handsome. But I still love myself.'"

For Bereal, this love includes kindness toward himself and toward his fellow artists, whose development, he fears, might be stifled by the paralyzing effects of too-early criticism and the capitalist pressure to build a "brand," if only because one has to pay rent and student loans, et cetera. "I'm still so young," the twenty-four-year-old says, "and I really hope that people I respect give me the grace to grow and learn as an artist."

Casey Gerald is the author of the memoir There Will Be No Miracles Here (2018).

All photographs from the series The Black Yearbook 2020–21

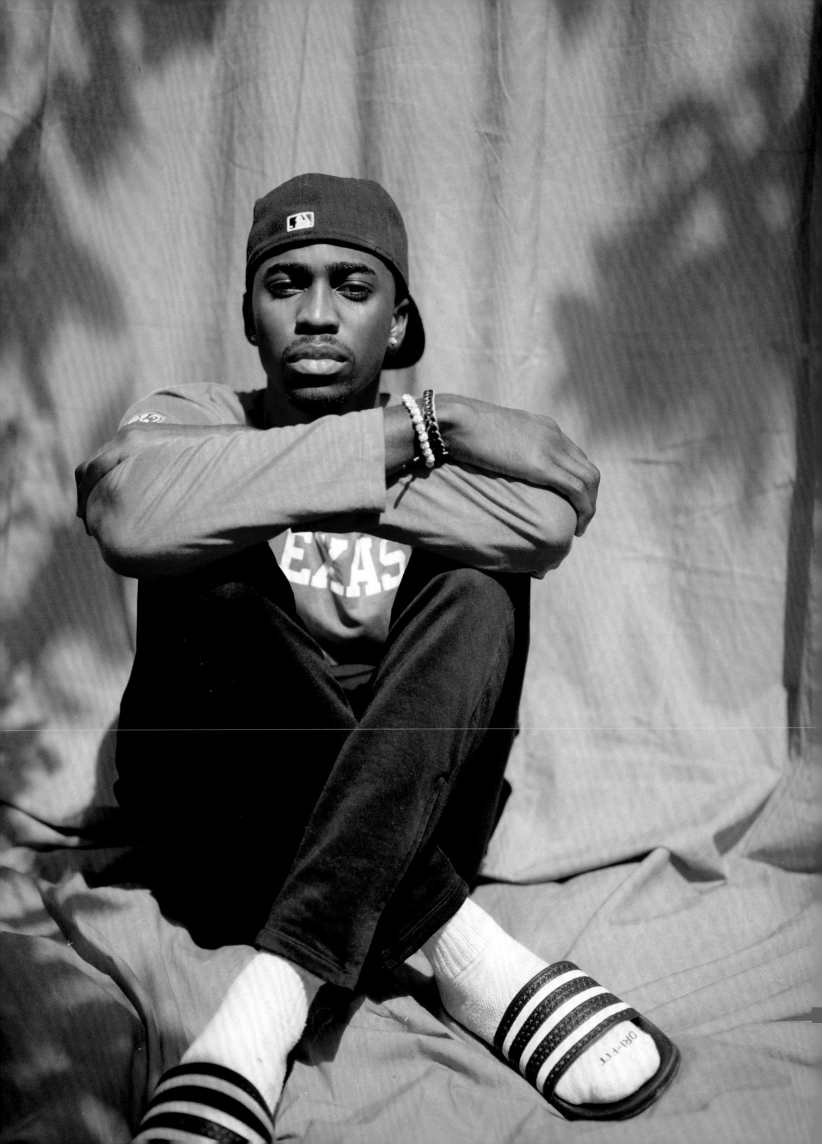

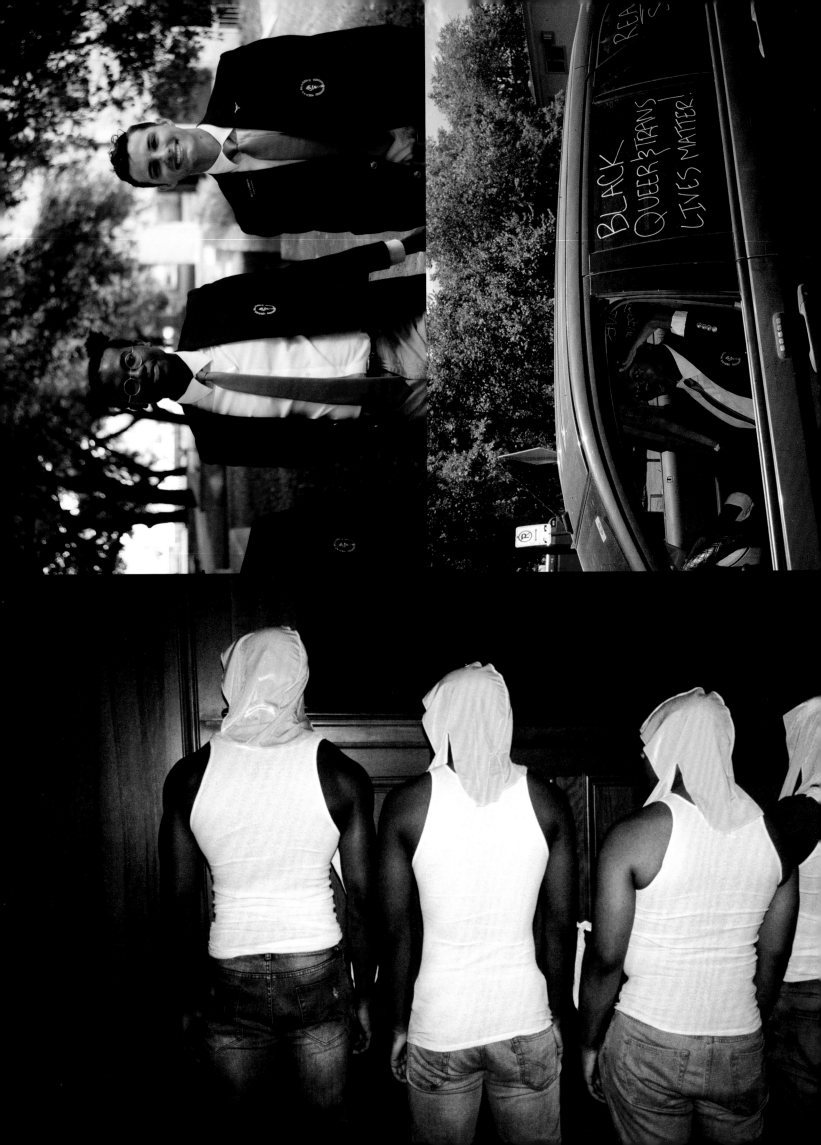

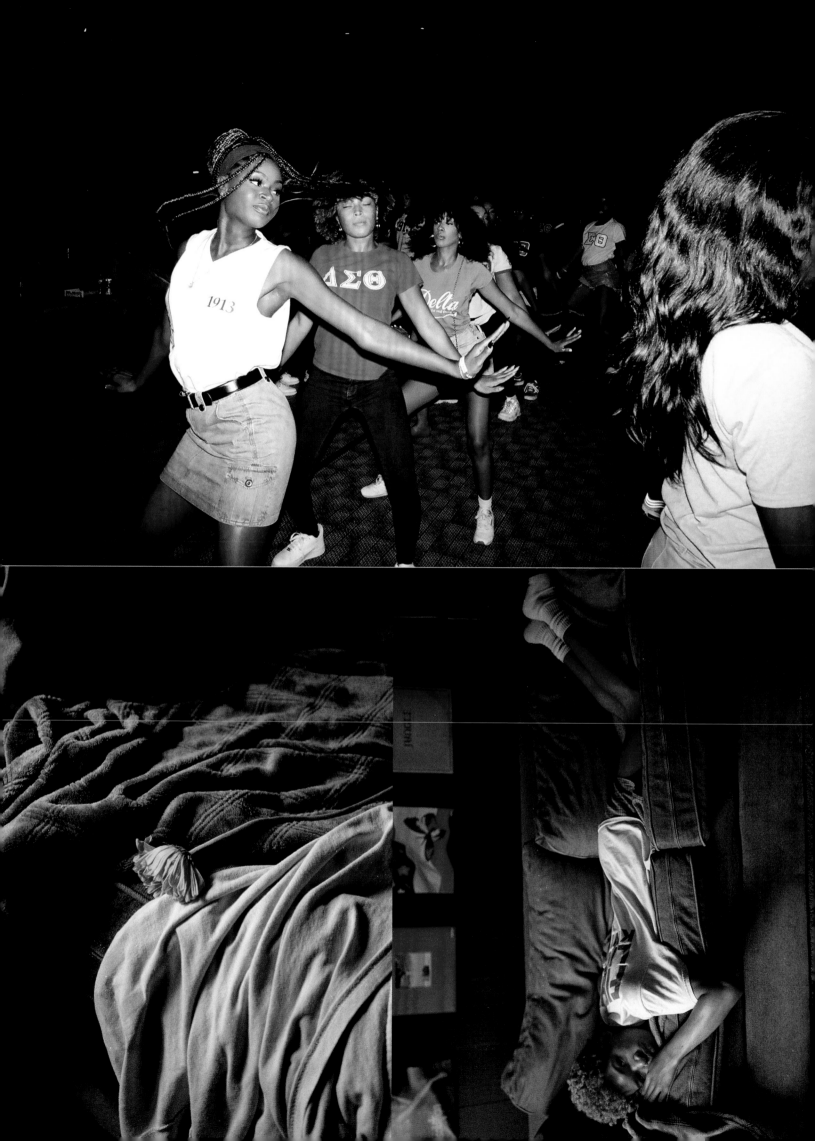

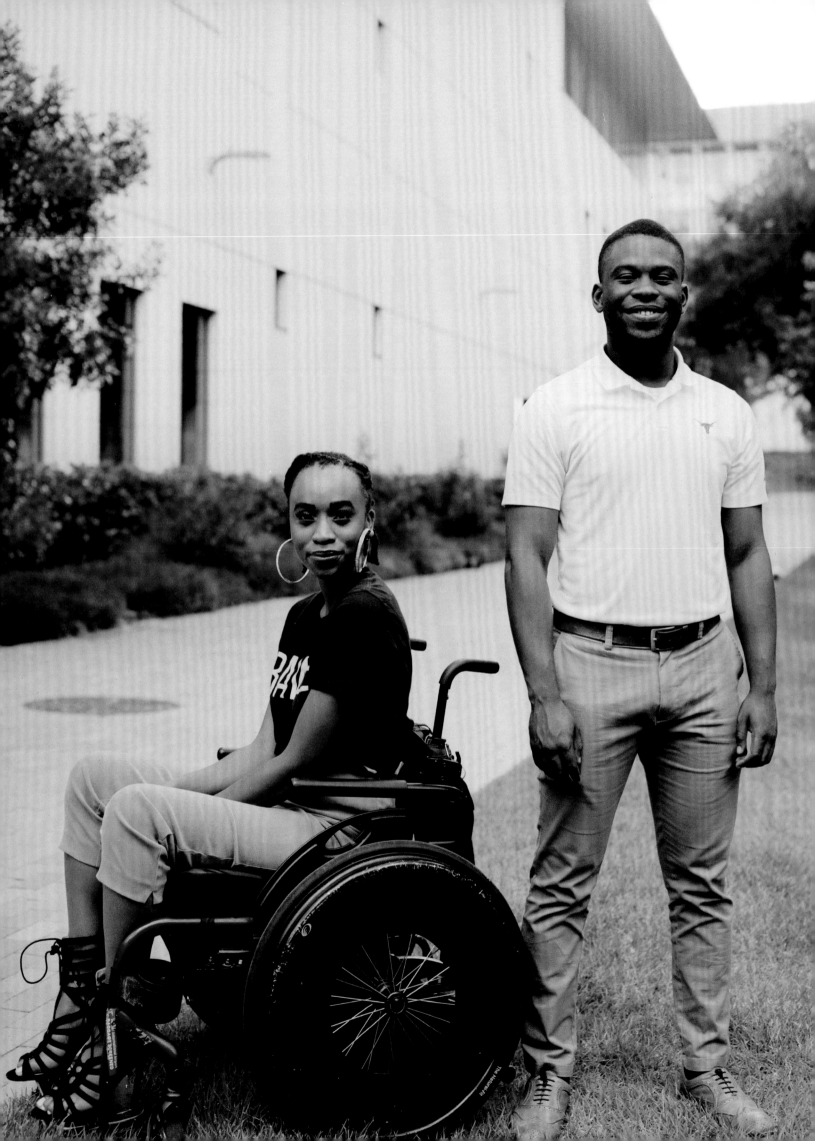

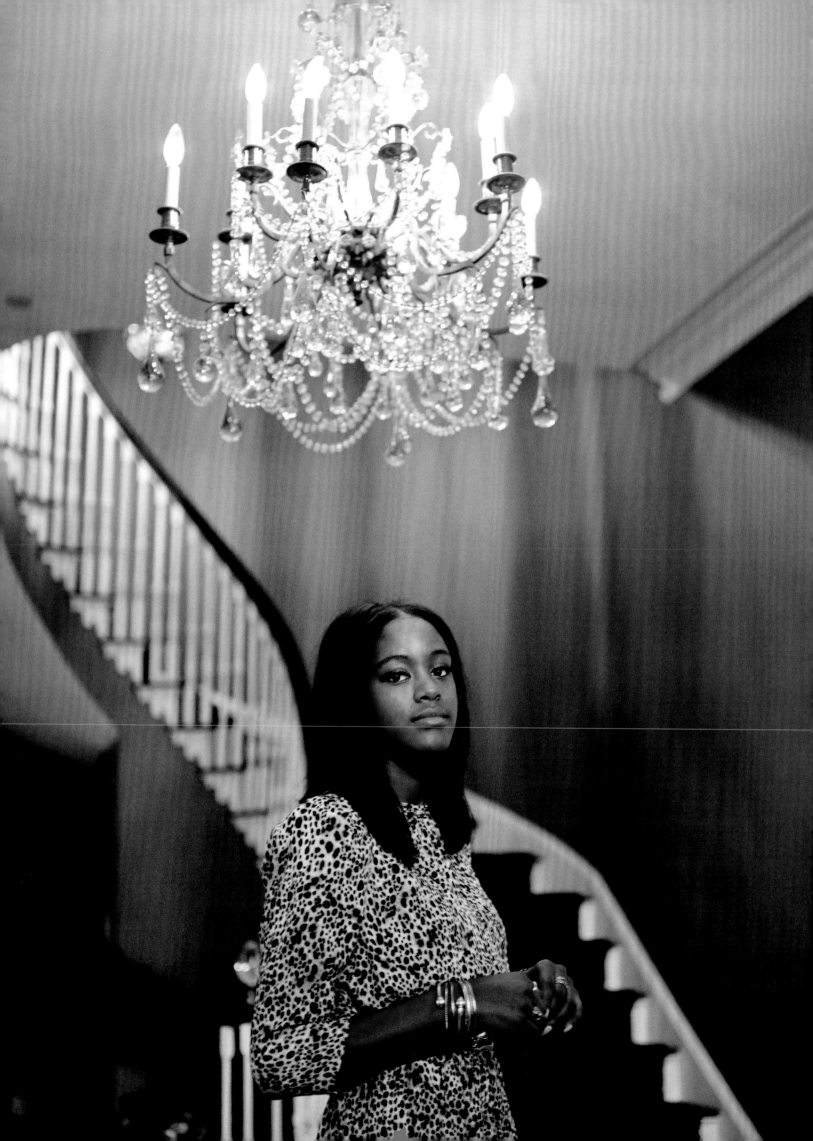

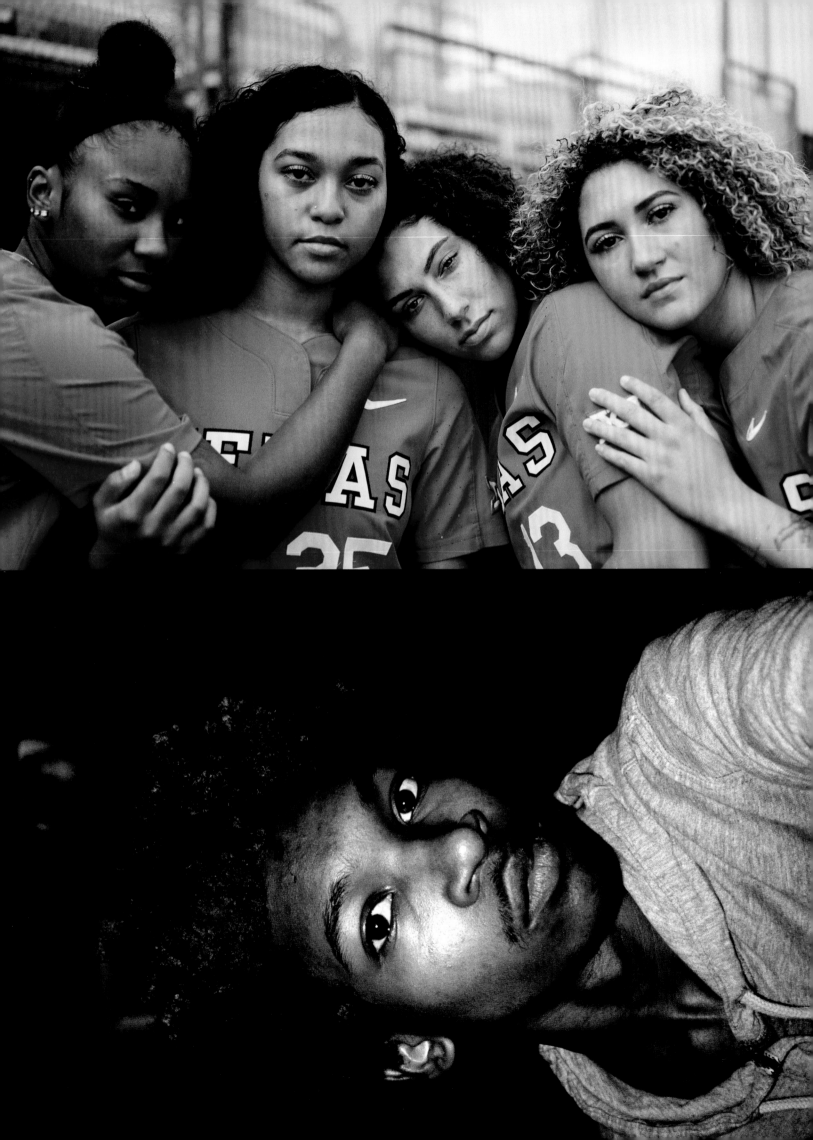

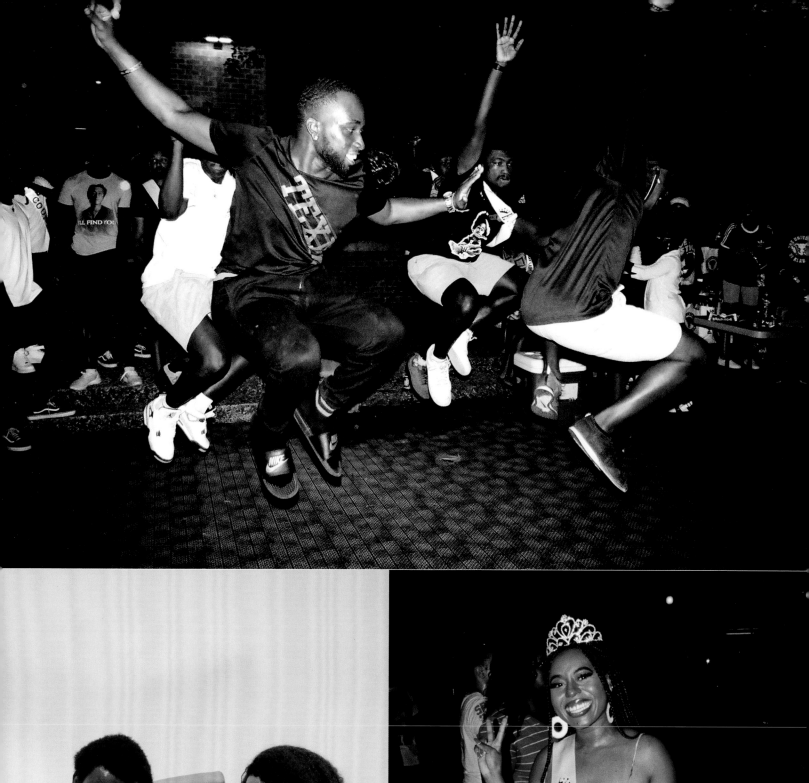

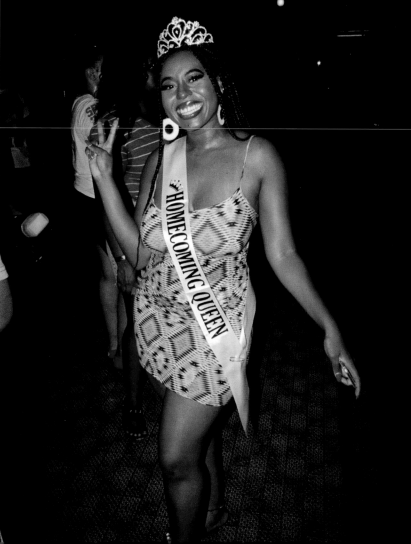

Eikoh Hosoe

Mythic Worlds

In his collaborations with influential literary figures and performers, Hosoe created surreal scenes that invoke the fantastic.
Lena Fritsch

Kazuo Ohono, a visit to the home of Yutaka Haniya III, 1995

It is said that the *kamaitachi* spirit resembles a weasel, rides on a whirlwind, flies through the air, and moves so incredibly fast that before you know it it's already gone. With strong and sharp claws, the invisible beast attacks suddenly and sucks blood from its victim's wounds.

Such a *kamaitachi*, half-naked and with its clothing blown up by the wind, jumps high in front of a group of curious farm children. Darkly surreal, a female head appears under a male arm and stares at the viewer, her eyes wide open. An androgynous figure runs across Tokyo. A young woman sits pensively between portrait paintings and striking busts with crying faces. Hauntingly poetic and depicted in high-contrast, these scenes tell of human physicality, sexuality, and a wide array of emotions. The images, by the legendary Japanese photographer and filmmaker Eikoh Hosoe, are expressive, subjective, and mythic; they whisper, speak, and shout fantastical stories that engrave themselves in the viewer's mind.

Brought up in a Shinto shrine where his father was a priest, Hosoe, who was born in 1933, came to photography at a young age. He borrowed a camera that belonged to his father, who supplemented

Hosoe communicates memories and personal realities, challenging conventional notions of photography.

his income during World War II by taking photographs at festivals and graduation ceremonies. In 1951, as a teenager, Hosoe won the inaugural Fuji Photo Contest and first gained widespread attention in the photography world with his 1960 solo show *Man and Woman*, at the Konishiroku Photo Gallery, featuring stylized nude compositions that reflect his career-long interest in the human body. Hosoe's fascination with the body's forms, movements, and eroticism is evident also in what was to become his best-known series: *Ordeal by Roses* (1961). The theatrical photographs featuring the writer, actor, and ultranationalist Yukio Mishima, a tireless promoter of his celebrity image who would commit ritualistic suicide through *seppuku* disembowelment a few years later, convey a sense of dark eroticism. "The series made me famous, and I started to work with Light Gallery in New York," Hosoe told me recently. Selling prints overseas enabled him "to live a good life and get married." And, he recalls, "Mishima came to my wedding and gave a rather ironic speech."

For his equally striking series *Kamaitachi* (1965–68), Hosoe collaborated with Tatsumi Hijikata, one of the founders of the experimental dance form *butoh*. The work is linked to the photographer's childhood memories of the war, when he was evacuated to the rural Tōhoku region. Hijikata, who grew up there, embodies the *kamaitachi* spirit of folklore said to haunt the rice fields. The dynamic scenes show the dancer running in the fields, dramatically jumping, hiding, or "stealing" a local farmer's baby, and they also often mirror Hosoe's own physical involvement, taking photographs while running or from unusual vantage points. Even today, elderly people in the village remember the photoshoots.

Soon after, Hosoe began to work with Ohno Kazuo, the other founding figure of *butoh*; this collaboration was to last for more than forty years. Another highlight in Hosoe's oeuvre is the series *Simmon: A Private Landscape* (1971), which features the artist and actor known as Simmon Yotsuya—a stage name inspired by the

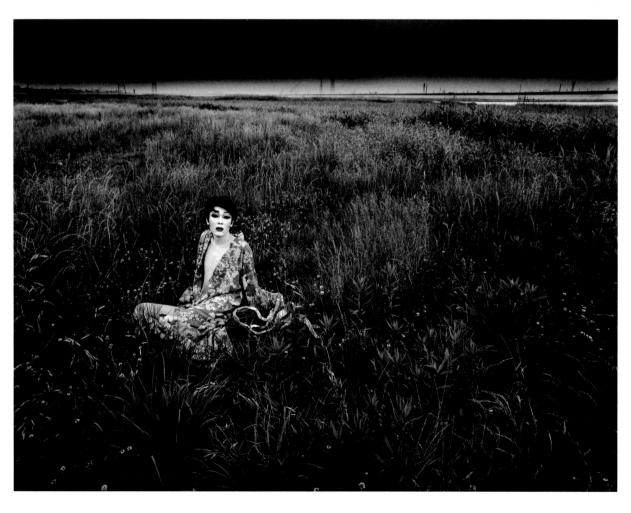

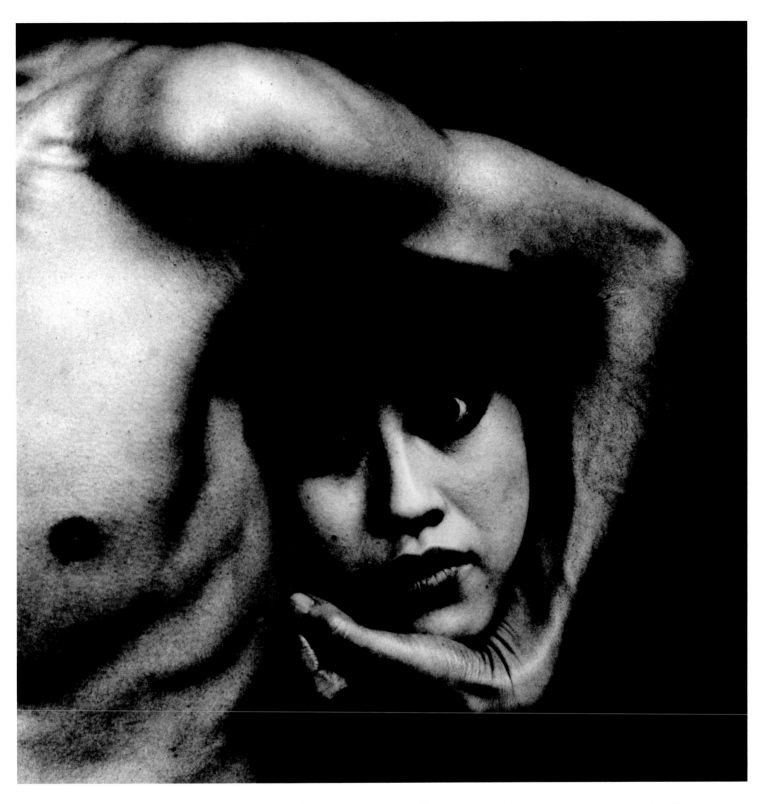

artist's love for Nina Simone's music and the Yotsuya district of Tokyo. The beautifully made-up, effeminate actor was a participant in Juro Kara's avant-garde Situation Theatre troupe (Jōkyō Gekijō). Hosoe photographed Simmon Yotsuya in different areas of Tokyo, including around Kannon Temple in Asakusa. His energetic poses and facial expressions are juxtaposed with the urban landscape, blurring the lines between the real city and passersby, on the one hand, and the performative and photographic narrative on the other. This results in an expressive aesthetic that links the performer's inner "private" side with the outer "landscape." In contrast to *Kamaitachi*, Hosoe has described the series as a recollection of his adolescence when he had returned to Tokyo: "I have created works based on special encounters with photographic subjects. At that time, I had met Simmon Yotsuya—through him, the adolescent scenery of Tokyo awakened from my memories and was turned into a work of art."

Hosoe communicates memories and personal realities, challenging conventional notions of photography. In 1950s and 1960s Japan, his work embodied the hunger for a subjective and experimental form of photography in opposition to the then dominant trend of social realism. The photographers' group Vivo, named after the Esperanto word for "life" and cofounded by Hosoe in 1959, is an early manifestation of this hunger. Like Hosoe, its five other members, Kikuji Kawada, Ikko Narahara, Akira Sato, Akira Tanno, and Shomei Tomatsu, had participated in a group exhibition titled *Jūnin no me* (Eyes of Ten) at Konishiroku Photo Gallery two years earlier, organized by the photography critic Tatsuo Fukushima. The Vivo artists shared an office, a manager, and a darkroom in East Ginza, Tokyo. Despite existing for only two years, this office became the epicenter of a new subjective style of photography, whose protagonists were soon referred to as the Image Generation and became highly influential in the history

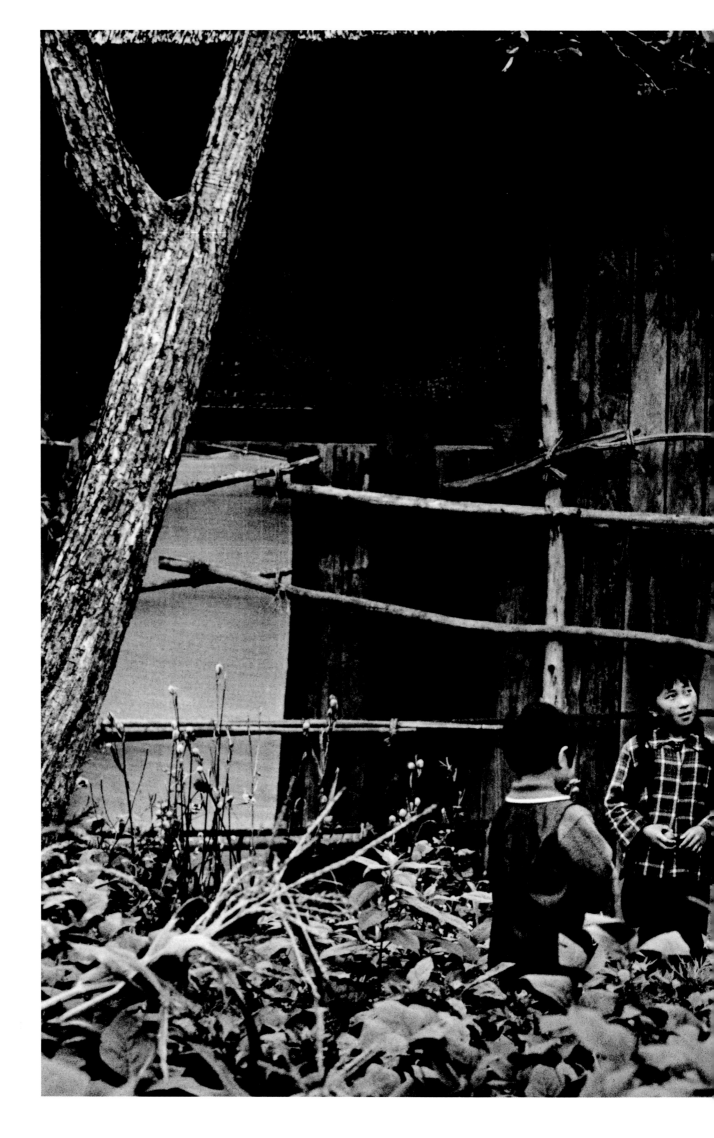

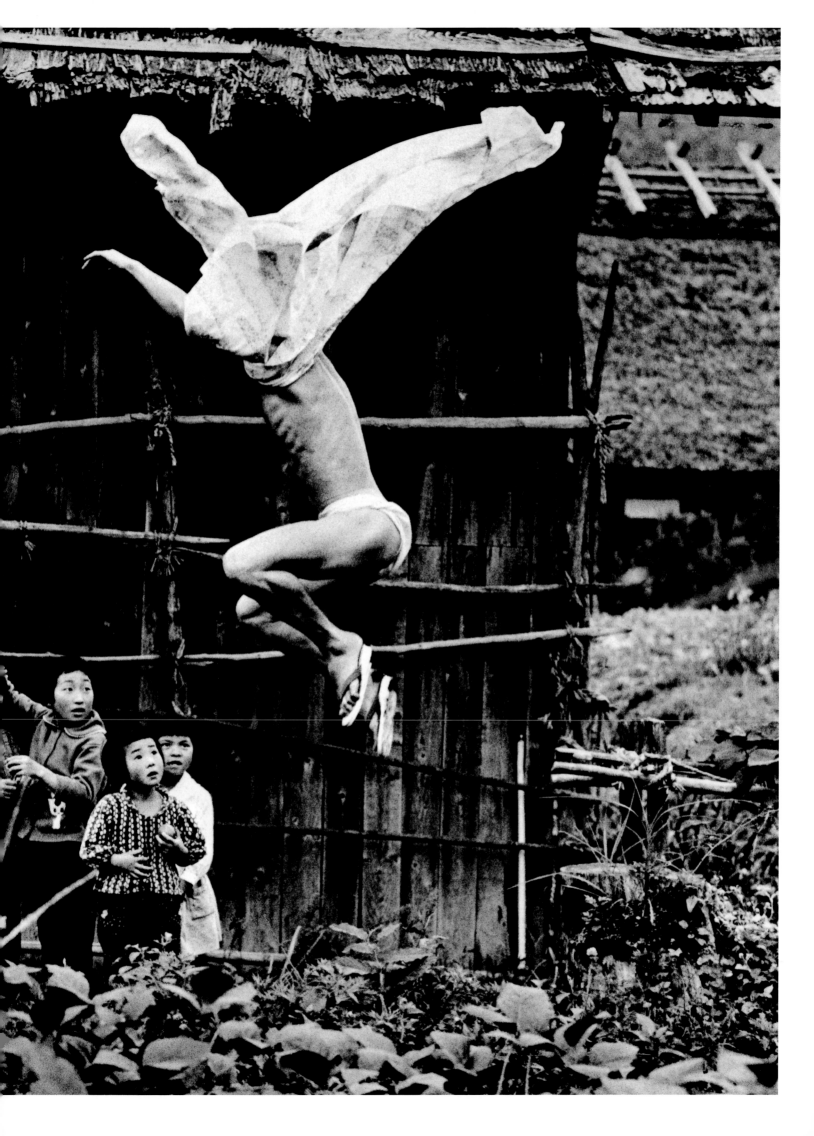

of Japanese photography. As the critic Kotaro Iizawa once wrote, the Vivo members "gave the image its independence."

Whether presented individually or as a series, in exhibitions or photobooks (often designed by key figures of Japanese graphic design, such as Kohei Sugiura and Tadanori Yokoo), Hosoe's photographs grab viewers and lead them into a cinematic world. None of the series have a beginning, ending, or story line; however, most of them convey a strong narrative quality. But whose stories do they tell? They are born out of collaborations, while also recording a specific time and place. The narratives are based on Hosoe's artistic choices in terms of photographic angle, perspective, light, shadow, background, and printing techniques in the darkroom just as much as they come into existence through the facial expressions, spontaneous gestures, and movements of the photographic subjects. Hosoe creates an inspiring atmosphere in which the performers and the photographer engage in a fantastical Ping-Pong match, passing ideas back and forth to each other.

In a recent monograph titled *Eikoh Hosoe: Pioneering Post-1945 Japanese Photography*, edited by Yasufumi Nakamori, the curator Christina Yang proposes viewing Hosoe's expansive practice as "exquisite world-making"—I suggest attributing this act of "world-making" to Hosoe as well as to the people in front of his lens, situating both on a par with each other. It is no coincidence that the subjects of Hosoe's best-known photographs are strong characters who enjoy working with their bodies and faces, be they dancers, actors, or public figures such as Mishima, who transformed his physique through bodybuilding. Hosoe is aware of the photographic

Dramatic and dreamlike, Hosoe's imagery remains radical, powerful, and moving—it deserves to be discovered by a wider audience.

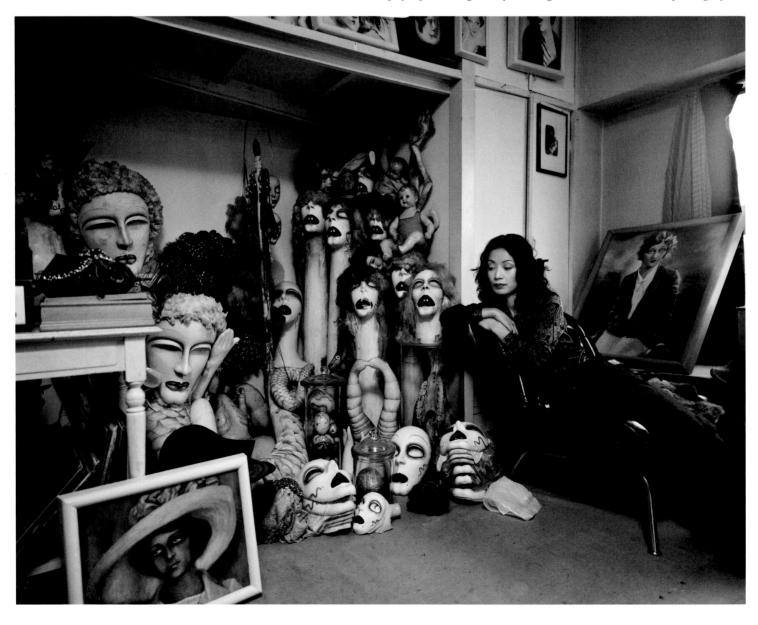

subjects' power during the creative process; unlike his peers, he has credited Hijikata, Mishima, Simmon Yotsuya, and others, acknowledging them as equal collaborators. With many of them, he developed a friendship. When I asked Hosoe a few years ago what he likes best about photography, he pointed first to his subjects, responding that "the most interesting and attractive aspect of photography is the simple joy of the people who are photographed. I have always liked human relationships." Storytelling in Hosoe's photography is based on an indescribable fantasy world that exists between the photographer and photographic subject(s); a unique moment of space, time, and feeling is captured on camera, during the vivid exchange of ideas.

This March, Hosoe will be ninety years old. With his distinct visual language, pioneering collaborative approach, and relentless activity promoting photography in Japan—including through education and copyright protections—he has been one of the country's most influential photographers since the postwar era. Hosoe has inspired his peers as well as younger generations of artists. Kikuji Kawada, a legendary photographer himself, who is best known for his experimental photobook *Chizu* (The Map, 1965), described Hosoe as someone who "searched for a new world of thought based on the eye," creating "dramatic evidence and unforeseen stories within overwhelmingly photogenic and poetic frames." It is telling that, having aspired to be a diplomat and also having won Tokyo's very first English speech contest as a child, Hosoe chose the Japanese character *ei* for his pen name, Eikoh, which is also used in the term *eigo*, "English," suggesting internationality. According to Kawada, both the Vivo office and what is now the Tokyo Photographic Art Museum would probably not have been founded without Hosoe. Daido Moriyama, who at the beginning of his own photographic career in Tokyo assisted Hosoe, argues that before Hosoe, the Japanese photography world was dominated by a type of photography that had "a strong sense of documentary and was strictly not staged. Hosoe confronted this, creating theatrical, staged photographs based on collaborations with the photographic subjects. It was a major achievement."

With his openness, beginning in the late 1950s, to viewing photography as a form of creative collaboration, Hosoe was well ahead of his time. After early attention in the United States and Europe, however, his work has not been exhibited on a large scale outside of Japan. Dramatic and dreamlike, Hosoe's imagery remains radical, powerful, and moving—it deserves to be discovered by a wider audience internationally, including all current and future photography lovers.

Lena Fritsch is the author of *Ravens & Red Lipstick: Japanese Photography since 1945* (2018). She is the curator of modern and contemporary art at the Ashmolean Museum, University of Oxford, and is currently a guest curator at the Mori Art Museum, Tokyo.

Yvonne Venegas
Sea of Cortez

Daniel Saldaña París

Returning to the place we came from is not as easy as it seems. It is not enough to take a flight and walk the streets we have walked so many times. There is no shortcut back. On the contrary, it is necessary to heed the exhortation of Constantine Cavafy's poem "Ithaca": "ask that your way be long." The past can be accessed only through symbolic deviations, through displacements and intermediations. This sometimes means representation, performance. To see long-lost friends from the past, imagine them in other bodies. Make them move as they never moved before.

Yvonne Venegas knows how to distrust the apparent immediacy of the image as a vehicle to the past. From her interrogation of the family archive to the reinterpretation of key works of the male photographic canon, Venegas's projects are crossed by notions of gender and class, and, in the case of her latest series, *Mar de Cortés* (Sea of Cortez, 2021–ongoing), by the economic history of the landscape, its exploitation and plundering. It is not surprising, then, that one of the settings present in this series is the Mexican town of Santa Rosalía, in the state of Baja California Sur, a place where her maternal grandfather, an orphan, lived.

"My grandfather's story was retold always a bit superficially. Near to my fifties, I realized I really knew nothing of the facts and had never visited the town. From that feeling emerged the idea for this project," Venegas says. "Part of my family died in the 1931 hurricane that hit the mining town of Santa Rosalía. My grandfather was sent to live with relatives in San Diego, and then came back, where he worked at the mine, got married, and had two children." The choice of subject for Venegas, as always, transcends the personal sphere to delve into the political. Founded in 1885 from a concession contract for copper extraction between the Mexican government and a French mining company, Santa Rosalía is scenographic. It is also a territory marked by mining, by a certain sense of uprooting, and by a tense relationship between public and private interests.

But Venegas avoids a pamphletary tone and chooses an indirect and nuanced exploration of this history. "I like to work with the surprise, walking and inhabiting the territory," she told me over the phone from her studio in Mexico City, citing the influence of Rebecca Solnit's *A Field Guide to Getting Lost*. The landscape shaped by the economy does not appear in opposition to a pristine or ideal vision of nature; instead, both complement each other and engage in dialogue using a syntax in which the punctuation marks are bodies and shadows.

In this project, Venegas works with professional actors and dancers—as well as some family members—in the creation of a dreamlike detour to return to an impossible origin. Along with performance, architecture also appears as yet another point of dialogue forming the backbone of this series, and in addition to Santa Rosalía, Venegas returns to another of her flagship territories: the city of Tijuana. Moving between color and black-and-white photography, between memory and history, between the body and the landscape, *Mar de Cortés* is an exercise in freedom and intelligence.

Daniel Saldaña París is the author of the novels *Among Strange Victims* (2016) and *Ramifications* (2020).

Translated from the Spanish by Enrique Pérez Rosiles.

Hands and Gardenia, 2021

Lia in Mirror, 2022

Christ's Arms, 2003

Azzul with Fan, 2022

Explosion in San Marcos, 2021

All photographs from the series *Sea of Cortez*
Courtesy the artist

For more than fifty years, Charles "Teenie" Harris created a vivid record of Black life in Pittsburgh. Now, a major archival project stands to reveal the scope of his vision.

The Edges of Memory
Tiana Reid

Three women at the Beauty
Shop Owners' Fashion
Review at Schenley High
School, 1945

Sometime in the middle of the last century, Charles "Teenie" Harris became known for often taking only one picture of his subjects, and was aptly nicknamed "One Shot" by the former mayor of Pittsburgh David L. Lawrence. "He was fast," Charlene Foggie-Barnett, the Teenie Harris community archivist at the Carnegie Museum of Art, told me over Zoom in late October 2022. "He'd run in and say, 'Get together, everybody, I'm only gonna take one shot.'" With a determined energy, Harris took "one shot" many, many times in his long career, capturing the ordinary beauty of Black life in the city.

Professionally, Harris started out at the Washington, DC–based *Flash Weekly Newspicture Magazine*, but he had been exposed to photography since he was a small child. For more than forty years, Harris was the leading photographer for the *Pittsburgh Courier*, one of the country's largest Black newspapers. At the *Courier*, he worked on assignments ranging from the civil rights movement (protests, rallies, and marches) to local events such as birthdays, community meetings, cultural programs, and sports activities. Intersecting with the lives of innumerable Pittsburgh residents as a street photographer, studio photographer, and photojournalist, he made note of what he saw as a member of Pittsburgh's Black communities, touching on themes of sexuality, religion, intimacy, memory, slavery, and more. He lived for ninety years, nearly the twentieth century in its entirety. His work poses the question, How can photography be conceived as a history of experience?

Harris's presence in Pittsburgh's historically Black Hill District, Speed Graphic camera in hand, was ubiquitous. As exclaimed in *He's a Black Man!*, an early 1970s Sears Public Affairs radio series, "There may very well be a Black person in Pittsburgh who hasn't had his photo snapped by 'Teenie' Harris, but that

would more than likely be a Black person in Pittsburgh who hasn't had his picture taken at all."

Through Harris's eyes, the pressures of historic events including the Great Depression, the Great Migration, Black freedom struggles, civil rights campaigns, World War II, and Jim Crow were given rich visual references. Harris captured the contours of political life: a Black elder named Mary Reid holding a note defaced with swastikas, reading "Kill All Blacks" and "Stop Niger [*sic*] Take Over"; a billboard advertising the 1968 Poor People's Campaign demanding low-income housing and a moratorium against redevelopment in the Hill District; and a 1970 broadside of the Black Panther manifesto. He also photographed cultural icons when they passed through a deeply segregated and heavily policed Pittsburgh, a city he rarely left: well-known musicians (Louis Armstrong, Dizzy Gillespie, Duke Ellington), politicians (John F. Kennedy, Eleanor Roosevelt, Richard Nixon), civil rights leaders and organizers (Dr. Martin Luther King Jr., Stokely Carmichael), dancers (Josephine Baker), singers (Lena Horne, Sarah Vaughan, Eartha Kitt), and athletes (Jackie Robinson, Muhammad Ali, Willie Mays). As the art historian Nicole Fleetwood writes in her 2011 book *Troubling Vision: Performance, Visuality, and Blackness*, "Harris's lens provides an alternative visual index of black lived experience of the twentieth century, one that does not rely on the familiar device of photographic iconicity."

In 1937, Harris opened his own studio. In addition, he regularly freelanced for advertising agencies and insurance companies in order to make ends meet given the scant resources on offer from the Black press. Still, roaming around Black Pittsburgh, he made photographs that were just for him, for the sake of his craft, which often exceeded the limits of documentary photography and reportage. Harris's practice combined the ordinary, uniquely vibrant character of Black life, including such shiny events as family portraits, weddings, baptisms, and funerals, with the more quotidian subjects of work and birth. He took pictures inside hotels, nightclubs, homes, restaurants, boxing rings, and kitchens; on tree-lined, brick-paved, stoop-filled streets; at railroad yards, police stations, demolitions, groundbreakings, and picnics. He never stopped taking pictures.

The Carnegie Museum of Art's permanent Teenie Harris collection contains more than seventy thousand negatives from Harris's working career, spanning from the 1930s to the 1980s. Tens of thousands still need to be digitized; among the selection here are several previously unpublished images, part of a major scanning project underway at the museum. Some images from Harris's formidable photographic archive are online and searchable. They have woozily long titles describing what they depict (partly because the recording of this information is ongoing). Over the past twenty years, since the institution purchased the Harris archive in 2001 from the artist's estate (a wish of Harris's before his death), the Carnegie has searched for more details and identifications. The catalog listings, which continue to evolve as new information becomes available, come from oral histories done with people who appear in Harris's photographs or from research via the *Pittsburgh Courier* or *Flash Weekly Newspicture Magazine*.

Instrumental to the contemporary and historical Harris moment, as well as to the Carnegie, is Foggie-Barnett, who knew Harris and was photographed by him as a child in the Hill District. She describes Harris as a friend of her parents, Bishop and Mrs. Charles H. Foggie, who were civil rights leaders. "Teenie was just an everyday occurrence," she recalls, with pride. "It was not uncommon, for a lot of people, to have Teenie pop up at any time."

In 2006, when Foggie-Barnett read in the newspaper that the Carnegie Museum of Art was looking for children photographed by Harris, she was the only person who showed up at the museum. "Part of the concern, of course, was what is the Carnegie doing

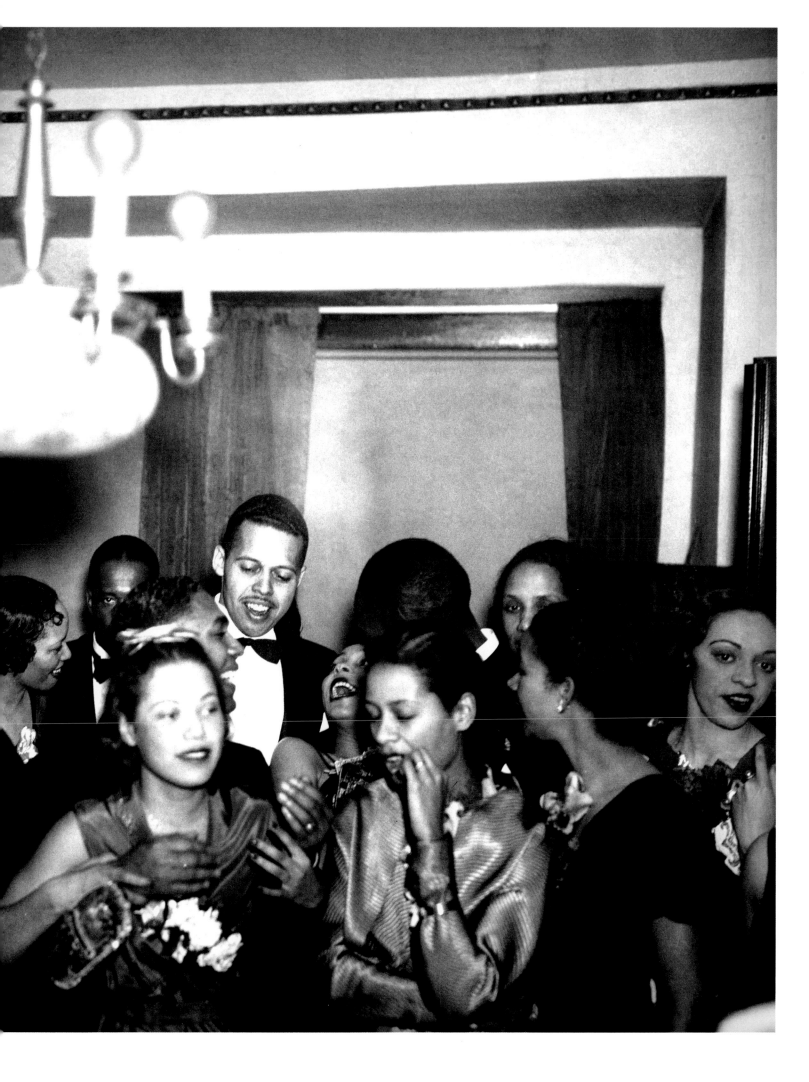

with these images?" she says. The recording of this history is urgent, but the critique of big institutions, which often excluded and exploited the Black community, is just as pressing. Many of Harris's acquaintances are nearing the end of their lives, but they still express an unsurprising distrust of institutional archives or a fear that they may not say the "right thing."

Foggie-Barnett ended up creating an oral history with the museum. "The archive had come almost exclusively unidentified to the Carnegie," she says. "And so, the first-person interviews and people talking about their lived experiences as seen through Teenie's lens was the way they were building the information of the archive. I got so excited by and so appreciative of how the staff treated the information. They were very delicate in how they asked questions and were very clear and sincere about what their intentions were," she explains. "I started bringing some people with me that they couldn't get to come down. And a lot of those were elderly people, like my original childhood hairdresser [Gloria Golden Grate], who had her own shop but was also one of the first Black models in Pittsburgh."

Foggie-Barnett began volunteering at the museum in 2006 and was hired in 2010 as the community archivist. She is now a well-respected steward of the Harris archive, involved in preserving, curating, and broadening the collection's scope and community relevance. Along with the archivist Dominique Luster, she co-organized *In Sharp Focus: Charles "Teenie" Harris*, a permanent exhibition in the Carnegie's Scaife Galleries that opened in January 2020. As a researcher studying the Harris archive, Foggie-Barnett conducts oral histories and coordinates outreach by bringing exhibition prints to nursing homes, delivering lectures in schools and on campuses, and giving tours of the exhibition.

At its core, Harris's picture-making practice was aimed at a Pittsburgh in transformation, shifting from a steel-producing hub

Through Harris's eyes, the pressures of historic events were given rich visual references.

A television playing
coverage of James Baldwin
at the March for Freedom
and Jobs in Washington,
DC, 1963

of industrialism to a city best described as postindustrial. As the
city changed, many tensions around segregation and desegregation,
for example, unraveled at the Highland Park pool. In the 1940s and
1950s, civil rights organizers in Pittsburgh staged demonstrations
involving interracial swimming. As the historian Joe William
Trotter Jr. notes in his essay "Harris, History, and the Hill,"
published in the 2011 catalog *Teenie Harris, Photographer: Image,
Memory, History*, white people harassed the swimmers. Harris
photographed many outdoor and indoor pools: some give off a sense
of leisure (glamorous poses, a hand on the hip), others focus on
sports (boys lined up at the edge of a pool for a swim meet), but all
are overburdened by the historical fact that municipal swimming
pools were crucial sites of racial violence during segregation.
The corresponding fear of Black people "contaminating" whites
loomed large.

Harris wanted you to see, but he also wanted you to listen
to the stories he was presenting in his art. "He is leaving clues, he is
revealing story lines and truths," says Foggie-Barnett. "He's making
a statement." Harris trains the eye to notice more idiosyncratic acts,
that mental montage of stills ever blowing in our head, at the edges
of memory.

A single Harris photograph can take the form of a
transgenerational account of the present. In one image, from
December 1954, Sabre "Mother" Washington, a formerly enslaved
woman, stands in her Conemaugh Street home on the occasion
of her 109th birthday. The image would be remarkable on its own,
but Washington, seemingly having just stood up from her floral-
patterned chair for the picture, and with her shadow imprinting
the living room wall behind her, gives the impression that she
is hovering, evoking the hauntings of the slave trade.

In other photographs, in which people aren't always as
readily identifiable, some looking directly at the camera and others

**Harris wanted you to see, but he
also wanted you to listen to the
stories he was presenting in his art.**

This page:
Swimmers, Pittsburgh,
ca. 1971; opposite:
Untitled, Pittsburgh,
ca. 1962
All photographs courtesy
Carnegie Museum of Art,
Heinz Family Fund

Looking at the subjects in Harris's pictures, we see people who find comfort and trust in a world where comfort and trust are never guaranteed.

seemingly posed, subtleties break through the frame: a Sylvania television playing footage from the 1963 March on Washington, forcing the viewer to take note of the technologies of representation. Harris's oeuvre chronicles historic events but also what the art historian Cheryl Finley calls, in *Teenie Harris, Photographer*, "glimpses of everyday life and the people who gave it vitality, dignity, and purpose."

Harris often provided visual language to interstices only he could see. Swirling night scenes—the subtle shift in brightness as lights twinkle over a foggy steel mill; sparsely populated urban landscapes; the subdued, anxious excitement of people standing around Greyhound buses for a march—reveal an aesthetic perspective that is an essential element of his work, cementing Harris's position as not only a photojournalist and studio photographer but an artist. Harris's rendering of Black skin and epidermal intensity was yet another sign of his creative virtuosity. Foggie-Barnett informs me that Harris used dodging and burning techniques in the darkroom so that Black skin would develop in rich shades.

As *The Black Press: Soldiers without Swords*, a 1999 documentary film by Stanley Nelson, illuminates, Black print culture played a determining institutional role in fighting white supremacy, especially during the twentieth century. Photographs are not only visual archives of the past but the axis on which people represent themselves, or see themselves represented. In *Teenie Harris, Photographer*, the historian Laurence Glasco describes Harris as a people person who often used comedy as a way to deflect attention from his four-by-five-inch handheld camera. Looking at the subjects in Harris's pictures, we see people who find comfort and trust in a

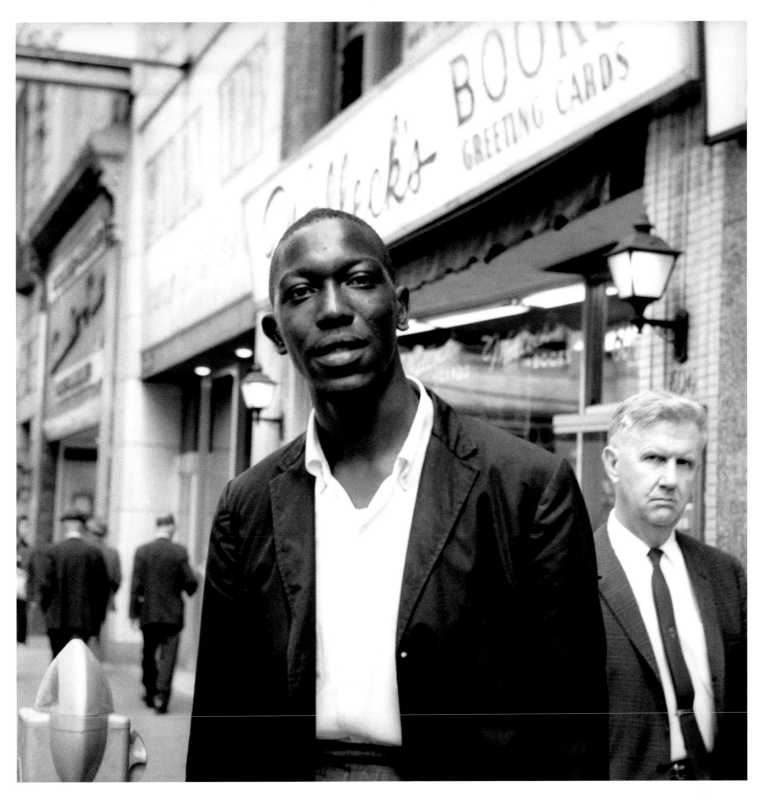

world where comfort and trust are never guaranteed, especially considering the ethnographic exploitation at the time by many American photographers slumming it for the shot.

Yet another important instance of Harris's representation of the ill-represented: "He has an array of photos of the LGBTQ+ community that most people didn't know existed," Foggie-Barnett tells me. In 2018, Black Artists' Networks in Dialogue (BAND) Gallery, in Toronto, exhibited Harris's work in a show called *Cutting a Figure: Black Style through the Lens of Charles "Teenie" Harris*, which featured midcentury scenes of queer and transgender aesthetic culture, such as the drag performers "Gilda" and "Junie" Turner in feathered costumes. "These images reveal the complete trust his subjects had in Harris," reads the online blurb. "Any spectacle related to outlandish dress is overshadowed by Harris's intimate and familial treatment of his subjects."

Harris's work was, and is, part of the fabric of the continued making of a heterogeneous Black narrative in Pittsburgh and beyond. One finds oneself changed by his visually quiet sociability. "He is the keeper of our history," Foggie-Barnett says. She encourages those who are young to explore Harris's archive and ask questions about what it means for them and their future. What remains will be up to them.

Tiana Reid is an assistant professor in the Department of English at York University in Toronto.

Gauri Gill
Acts of Appearance

Kamayani Sharma

Each May, the villagers of Jawhar District, in the Indian state of Maharashtra, come together for a festival called Bohada celebrated throughout the region. Donning papier-mâché masks, select members of the Kokna and Warli tribes put on ritual performances involving song and dance. Over a number of nights of pageantry, actors play the roles of various deities and demons, bringing to life well-known mythological tales. In 2015, the photographer Gauri Gill approached the brothers Subhas and Bhagvan Dharma Kadu, from a family of hereditary mask makers, with a proposition. She commissioned the Kadus to make masks representing contemporary everyday reality rather than fantastical episodes. Gill then photographed volunteers from their village wearing these masks, posing not as characters from legends but as themselves in improvised scenes.

Over more than thirty years of photographic practice, Gill has collaborated with communities and individuals on the margins to tell stories together, through stagings, inscriptions, and narrative duets. In *Acts of Appearance* (2015–ongoing), the traditional mask form—spanning species, ages, facial characteristics, and even inanimate objects—is untethered from its mythic moorings, connoting the passage of time and expressing moods in the context of ordinary life. A dog-headed man relaxes on the floor next to his seated friend, dozing behind a wide-open-eyed mask; a woman props her snake-form head on an arm as she reclines on a sofa, the posture a blend of human and serpent; a man with a TV for a face sits before an actual television, in a kind of Magritte-ean pun. Despite their desacralization, the masks evoke an otherworldliness, transforming the rural setting into a surreal landscape. The animal heads nod to the continuum between human and nonhuman that is part of Adivasi cosmologies, emphasizing the intimacies that vitalize lifeworlds.

Like Indigenous people everywhere, the Adivasi citizens of India have historically been disenfranchised by the state. In Jawhar, too, the crisis around access to food, water, and other public goods is severe. The exclusion from and subjugation within the political field is replicated in the visual one, where colonial and nationalist practices of ethnographic photography long objectified Adivasi individuals. By inviting the protagonists of her images to represent themselves through masquerade, Gill satirizes the violent legacies of the spectatorial gaze, denying it purchase.

Refusing to be seen and, consequently, known might be understood as a tactic of subversion. At a moment when surveillance based on facial recognition is encroaching on civil liberties in India, Gill's faceless antiportraits seem to mock the regime's attempts at identification. In an essay for the recent photobook of this series, Gill reflects on the existential conundrum of masking the self: "To whom does my face belong—me, or to the world that views me?" Disguise as dissent brandishes humor against the panopticon. It reverses the power dynamics of looking and affirms the sovereignty of the subject in cahoots with the photographer, now an ally, a fellow storyteller.

Pages 105–111:
Untitled (4), (17), (47), (52), (77), and (24), from the series *Acts of Appearance*, 2015–ongoing
Courtesy the artist and James Cohan Gallery, New York

Kamayani Sharma is a writer based in New Delhi.

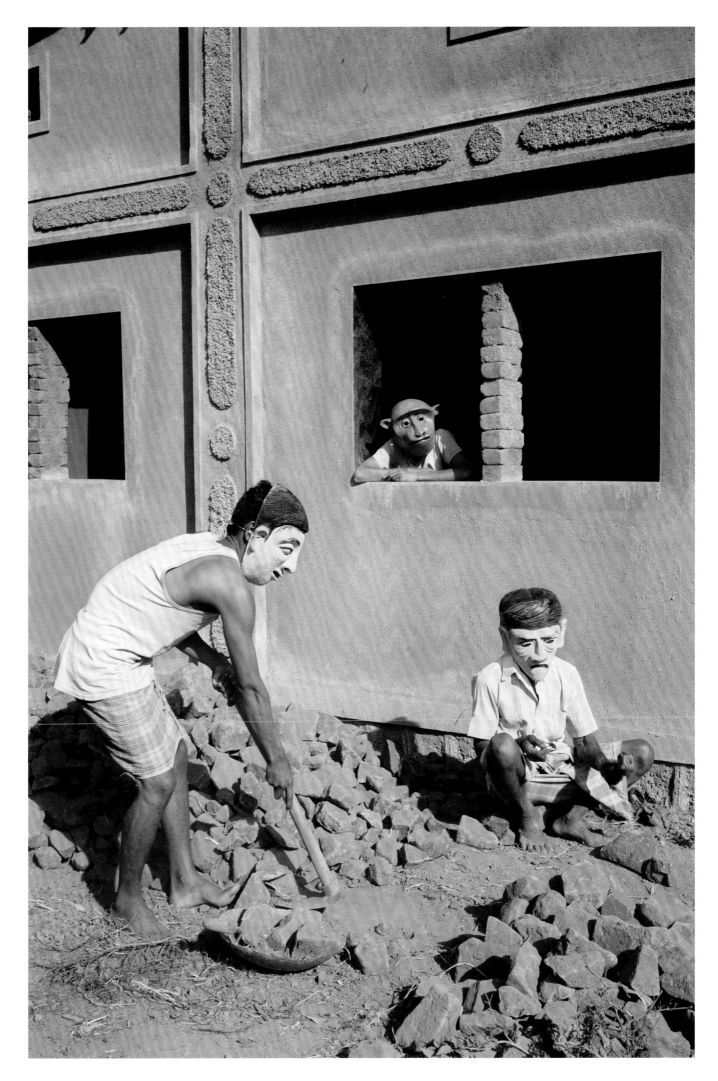

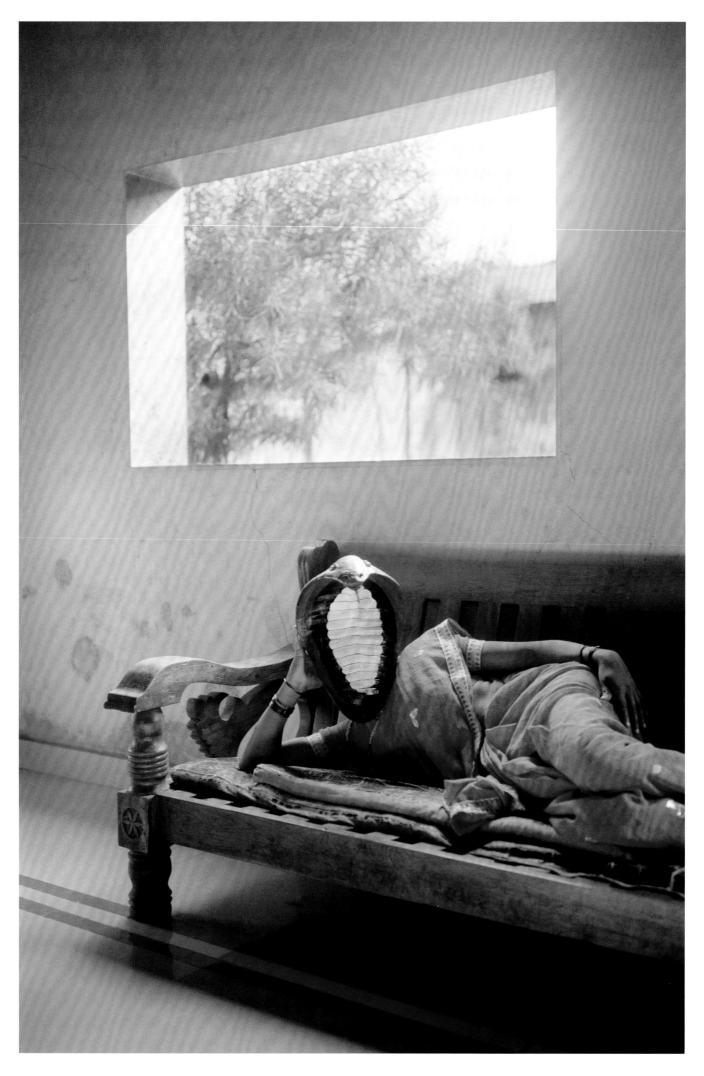

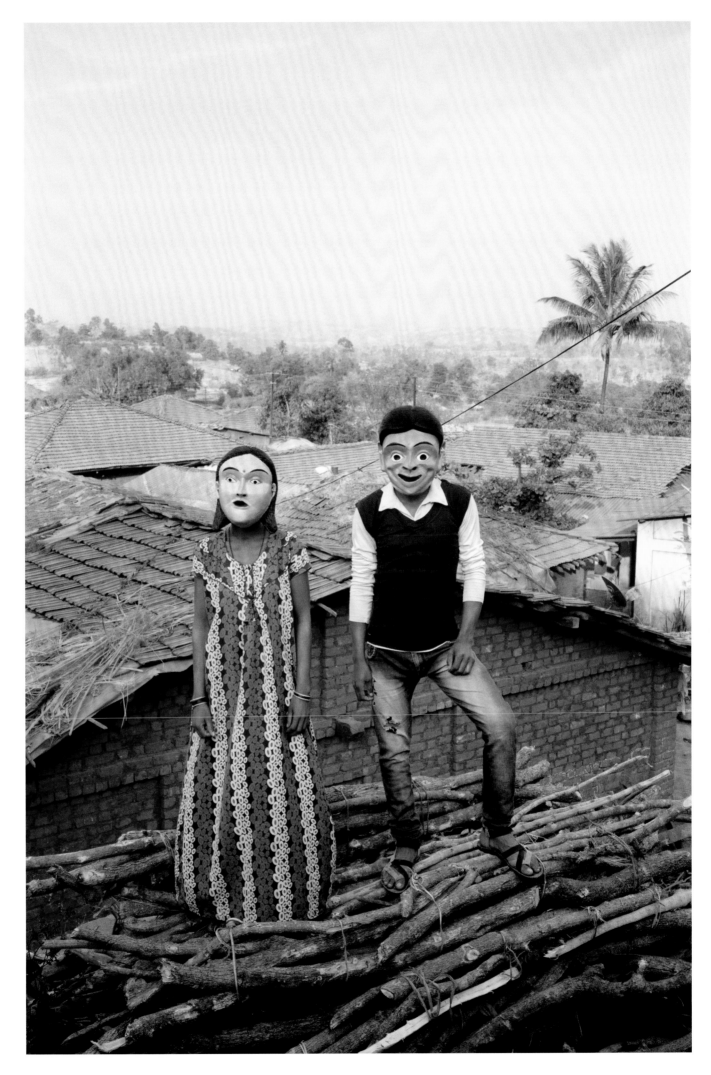

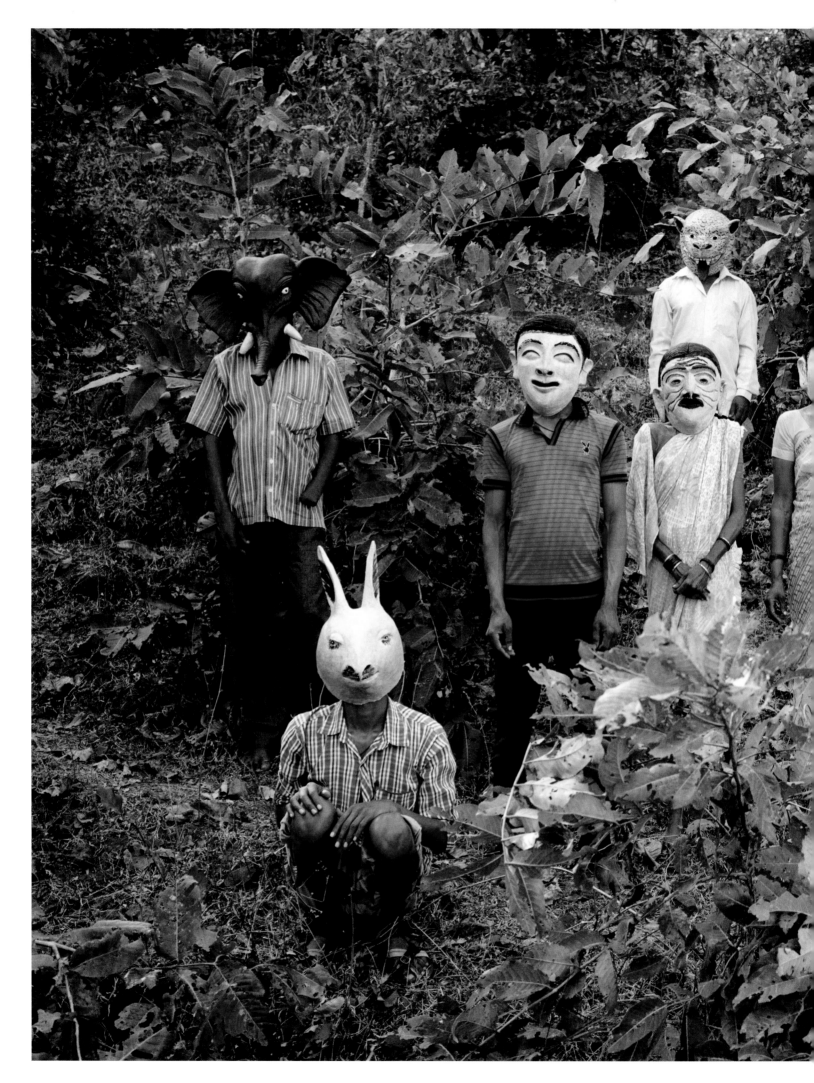

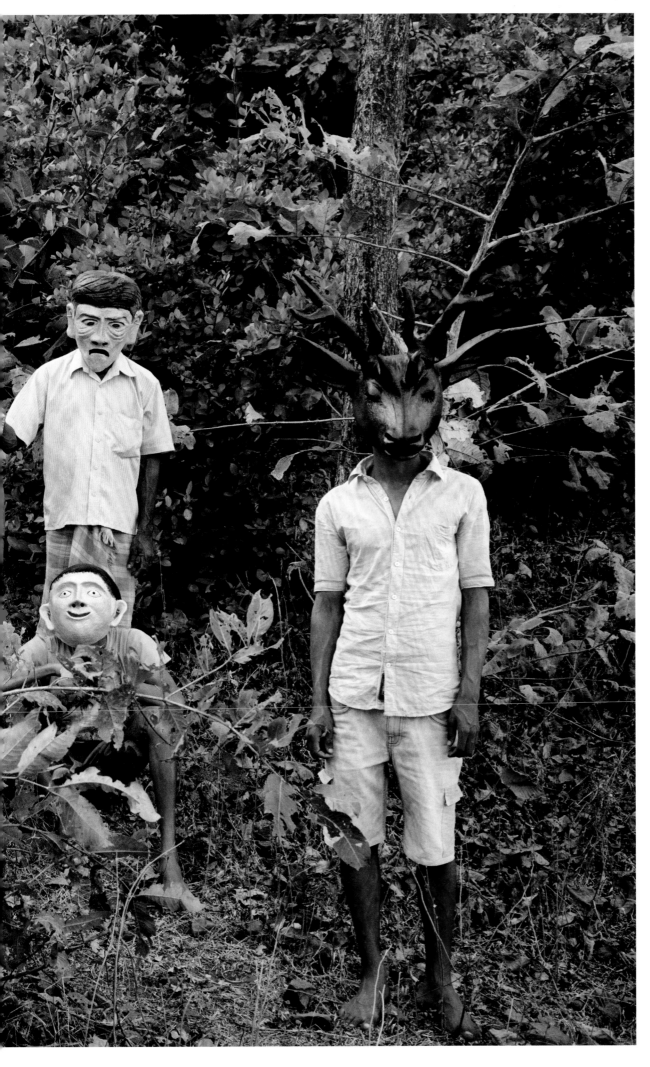

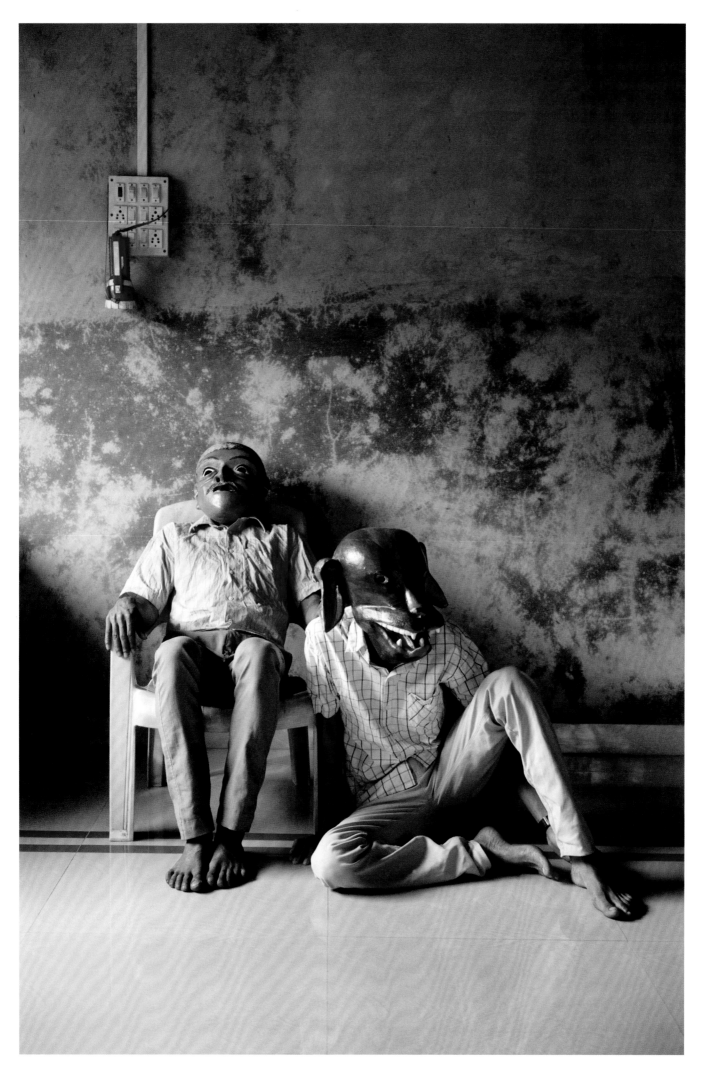

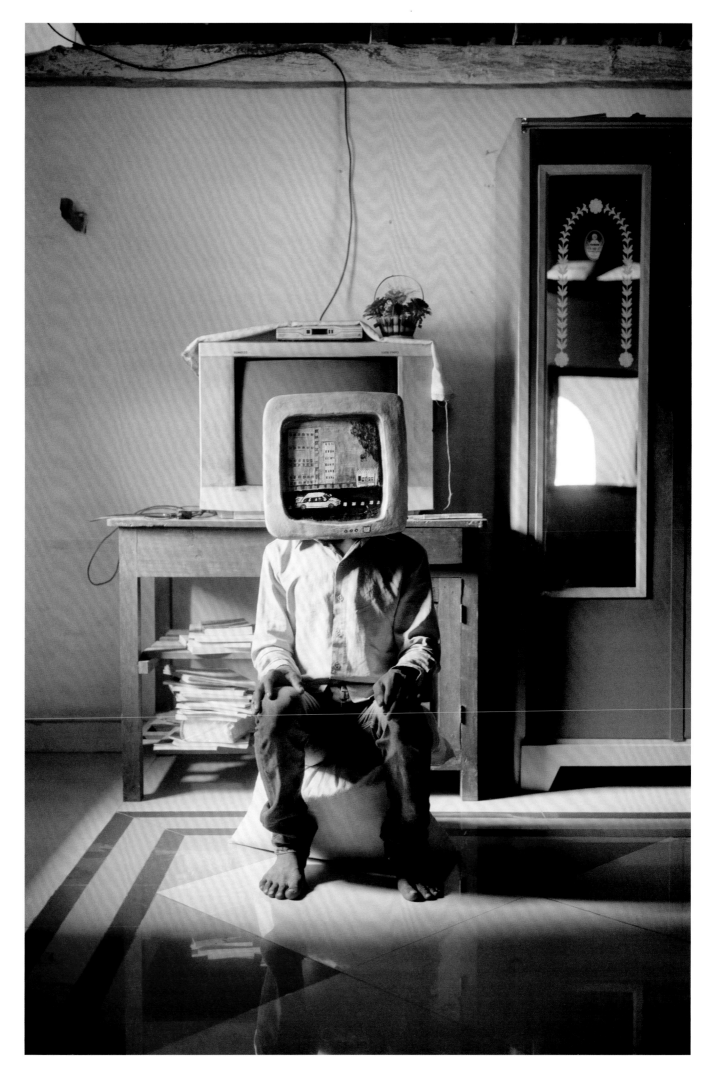

Mary Manning's favorite color is green. In the artist's photographs, we are shown an everywhereness of green. Green is neighborly, the most charitable color, according to Mary. Green is a pile of fallen ginkgo leaves fanning out on a car windshield. Green is the long open legs of a ladder. Green is the color of friends gathering in a beloved New York park, since destroyed by the city. Green is Nicole's studio T-shirt, Maia's sweater backstage, little Lucky's winter coat, Emma's snail. Even Mel's denim looks green from Mary's point of view, or maybe green is what happens to the viewer's gaze when spending time in Mary's world. Green is what happens!

Mary's work takes place at the threshold of joy and recall. The instant is stretched; the instant is what we wait for, like tulips come spring or a clean neck after a fresh haircut. The instant, as authored by Mary, is the first dance at a wedding, and other similar traditions that place an importance on affection and holding on, and how wonderful it feels to get dressed up. Because acknowledged in Mary's photographs, over and over, is the soft, conversational power of clothing. How a silk slip is so hospitable to that late summer breeze. How a dancer's arm is so compatible with a cap sleeve. How sneakers recur in Mary's images—often a record of comfort, wear, color, praise. Yes, praise. What is it about Mary's photographs that sounds like the words "I like your shoes"?

In one image, the cast of a play has returned to the stage for the final curtain call. On the right, a pair of audience hands is clapping enthusiastically. Applause and other responses that take place with genuine warmth (hugs, holding hands, smiling with your eyes closed) are all the subject of Mary's curiosity, which seems especially devoted to varieties of trust and closeness: good company on a coffee break, well-timed portraits of camera-shy friends.

In another photograph, a mother is joined on each side by her two daughters. "Happy Birthday" is being sung, the cake is on its way, and the glow—as seen by Mary—is somehow green. This everyday chronicle of waving your loved ones over and making a wish with a roomful of witnesses is central to Mary's work. As central as a favorite color.

"Favorite" holds many meanings for the artist. A surprise enchantment that calms the senses like a swan or someone else's bookshelves seen from street level. Other favorites might flow from the simplest acts, such as looking down (and seeing beautiful vestibule tile) or looking away from the art (and seeing a child at the Guggenheim who is just tall enough to peer over the edge of the museum's quarter-mile-of-concrete ramp). No longer needing to stand on one's tiptoes is a consequential moment in life. It's also ordinary and easily lost or passed over if you aren't paying attention. But Mary is. Mary's work is a document of . . . being. Of being!

Like the mother who asks her daughters to help blow out her birthday candles, Mary's photographs are testimonies, not just of togetherness but of sweet, good-sized customs (arriving with a bouquet; bringing a big bedsheet to the beach; parents at an art opening). Even—or especially—the artist's still life imagery favors themes of observance and cheer, and the ways in which nature counsels us, day after day. An ovation of thin trees marks winter's incoming frost. A variety of rose is called "love." A single red balloon in the woods seems to say, You've arrived. Party's here! Mary's poetic sensitivity toward story is full of bewilderment and magic. Everything is right there, up close, and yet a piece of metal wrapped around a pole looks like hidden treasure. Flowers out of focus are friendly ghosts. A New York vanity plate with the word "JOYS" could be read as "New York JOYS," which is one way of thinking about Mary's project. "New York Joys" by Mary Manning.

Mary Manning
New York Joy

Durga Chew-Bose

All photographs from the series *Grace Is Like New Music*, 2022
Courtesy the artist

Durga Chew-Bose is a writer based in Montreal.

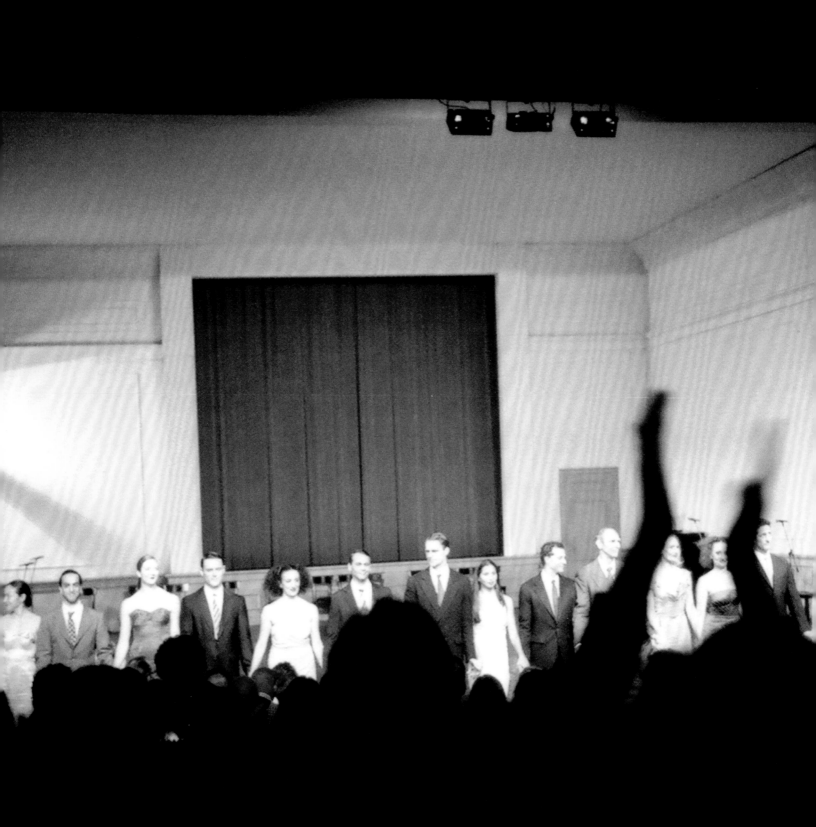

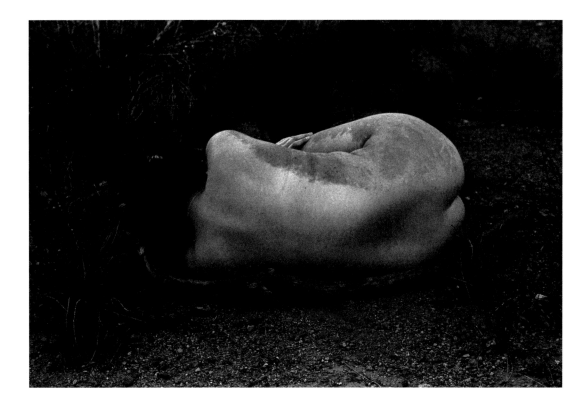

The PhotoBook Review

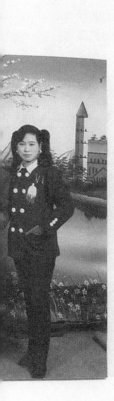

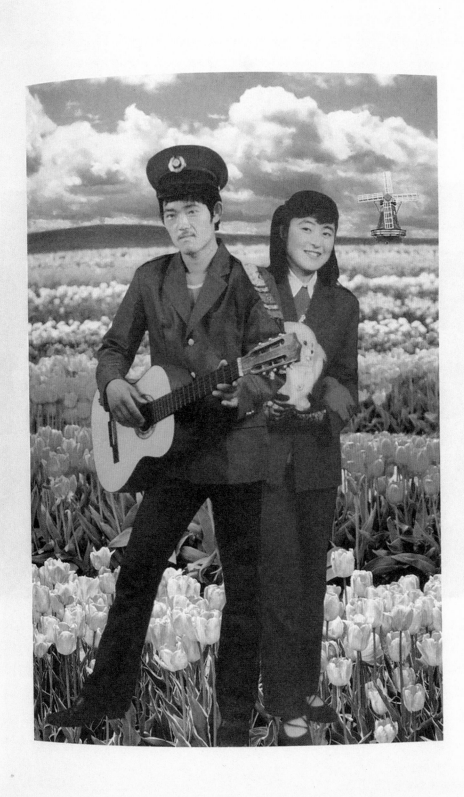

Always in Process, Never Finished

Alejandro Cartagena in Conversation with Bruno Ceschel

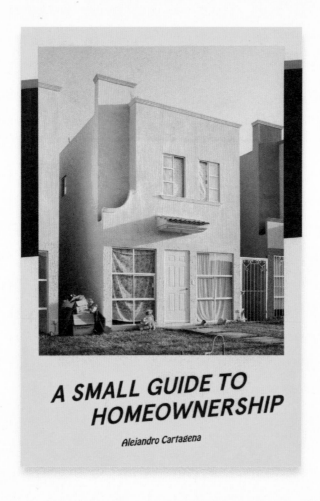

Alejandro Cartagena does a lot. He is a photographer. He is a publisher at Studio Cartagena and a copublisher, with Carlos Loret de Mola, at Los Sumergidos, a small independent bookmaker based in New York and Mexico. He self-publishes some of his own books; others are published by the likes of Skinnerboox, in Italy, and Gato Negro Ediciones, in Mexico. And sometimes he is *just* the author. He is an in-demand photobook editor and, most recently, as a cofounder of the NFT organization Fellowship, is deeply involved with the NFTs scene. Cartagena's overall practice as an indefatigable bookmaker—thirty-three books and counting— has produced a compelling network of inquiries about social, urban, and environmental issues related to Monterrey, Mexico, where he lives, and to Latin America in general. His work is at once geospecific and universal, methodical and loose, empirical and poetic. One morning last fall, during Printed Matter's Art Book Fair in New York, the publisher Bruno Ceschel met with Cartagena to try to make sense of it all.

Bruno Ceschel: **I want to start with your practice as a photographer. It looks to me that the methodology you adopt in your work bears a relationship to anthropological fieldwork—in your case, manifesting a structured way of analyzing complex social themes related to your own environment via the close observation of various, but specific, phenomena.**

Alejandro Cartagena: I think it comes from my training in visual studies, the idea of understanding an issue by visualizing the causes and effects of it. I would call my methodology a Google-era understanding of photography: if you pose one question to Google, it'll give you a hundred thousand ways of understanding what you have asked about. I thought that was an interesting way to develop my practice. Yes, I photograph housing developments, but how did those houses get there? What is the bureaucracy behind it, both public and private? After getting those houses, how do people then deal with transportation? What does it look like when you are using public transportation? What does it look like when you are using private transportation? What are the problems that stem from building those houses? There are environmental implications, effects on the waterways, et cetera. I felt this was an interesting proposition for documentary photography, to look at an issue by looking at all the other issues around it, even if they contradict the initial starting point. That vulnerability is very important for documentary photography, because it's not about truth—it's about an opinion. It is about making visible different ways of thinking about the same issue.

BC: **What's the main issue in your work, then, if you are able to describe it?**

AC: In most of my work, I would say homeownership.

BC: **But in a specific location, right?**

AC: Totally. It's concentrated in the metropolitan area of Monterrey, which is where I live. I've seen the changes to the city caused by suburbanization. It's a case study of what I was reading about urban theory at that time—how cities grow and decay and grow and decay constantly. It was, I guess, a coincidence that I was reading that kind of literature and seeing it play out in the real world. It was theory being made visible to me in my city.

BC: **With a speed that is probably specific to our times.**

This page:
Alejandro Cartagena,
*Fragmented Cities,
Juarez #2*, from the
series *Suburbia Mexicana*,
2007; opposite:
Cover of Alejandro
Cartagena, *A Small
Guide to Homeownership*
(The Velvet Cell, 2020)

I think of my practice as visual poetry— photographs of dying rivers alongside images of people in the bed of a truck.

AC: Exactly. It's suburbanization on drugs, literally.

BC: **While you talk about producing according to a methodology, and being prompted by academic discourse, your work reads to me as an art practice.**

AC: I think of my practice as visual poetry— photographs of dying rivers alongside images of people in the bed of a truck; pictures of people renting houses next to images of high-rises and empty lots in downtown Monterrey. The poetry comes from impromptu and open relationships that would be hard to justify in an academic context. In our culture, we have discrete, determined realms where things are supposed to happen. Art is the space where people can let go and do things that don't make any sense.

BC: **Or where people can feel, instead of understand.**

AC: Feel is important . . . and having no purpose aside from just an escape from order, escape from the idea of the known. It doesn't mean that all art is that way. But that's one of the things that I really love about art: I can propose ideas that in other fields would be rejected.

BC: **Do you see a sort of chaos as part of the strategy here?**

AC: Yes. I remember my first portfolio review, in 2004. One of the reviewers saw my work and said it looked like shit. The photos were really badly printed. He also said, "But there's a flavor to that. There's this organic-ness. The ideas are really good, but there's this unfinished nature to them." That comment stuck with me for a long time. I am conscious of the organic-ness of a narrative that is never finished in my work, which speaks of how I see Latin America—always in process, never finished.

BC: Some threads in your practice are ongoing: *The Carpoolers* **series is in its fourth volume, for example. And you have often used a book format drawn from various how-to guides—***A Small Guide to Homeownership* **(2020),** *Guía presidencial de selfies* **(Guide to presidential selfies, 2018), and** *A Guide to Infrastructure and Corruption* **(2017).**

El peso se ha depreciado 40.86% frente al dólar en cuatro años.

https://www.sinembargo.mx/01-10-2014/1131354

AC: The nod to the guide format is important to me because it's aligned with what photography is supposed to do: document, comment upon, and explain visually. But most of those books are an antithesis of a guide. They are complicated and nonsensical at times. After my master's in visual studies, I did the first volume of *Carpoolers* in 2014, followed by the *Infrastructure and Corruption* book, and a lot of subprojects that were never really completed. The idea of repetition is vital to my practice, not only in the representation but in ideas of themes and design. There's a big narrative arc that continues through each new publication, sometimes using the same images in different contexts, in different ways.

BC: On your website landing page, there is a list of titles in chronological order. There are your self-published books. There are books of which you are the author, but you're not the publisher. And then there are books that you edited, which sometimes you publish or others publish. But you present them as a whole. Can you talk about the relationship between your own practice as an image maker and a bookmaker?

AC: The idea of authorship is very interesting to me. When does authorship get fixed in photography? Does it get fixed when you take the photograph? Or does it get fixed when you edit and sequence a book? My website reflects that; I have authorship in all those books even if I might not be the photographer. Editing as authorship is part of my art practice.

BC: Finally, how does your work in digital spaces, Web 3.0 and NFTs specifically, sit within your practice?

AC: Web 3.0 and the digital space, for me, are a continuation of the idea of expanding photographic distribution. Photography is a medium that needs distribution. It needs to connect with people. And so, what really attracts me to NFTs and the digital realm is the expansion of a collector base. It's a place to educate, and a new source of people who can get excited about photography. That is something that photography in the NFT world does really well. What changes is the idea of ownership. That's why, also, I think photobooks work really well, and why there is a bigger market for photobooks than prints, and why there's a bigger market for NFTs than photobooks. Each offers the opportunity for ownership, but, each time,

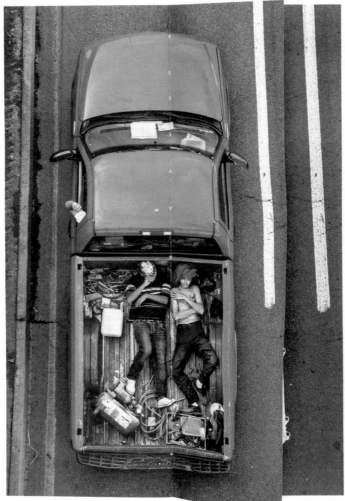
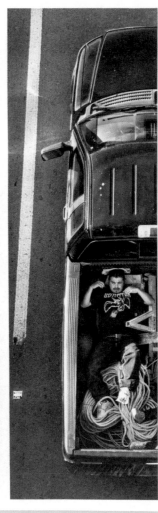

Spread from Alejandro
Cartagena, *Carpoolers #4*
(Los Sumergidos, 2021)
All images courtesy the artist

The idea of authorship is very interesting to me. When does authorship get fixed in photography?

it's a broader opportunity. Prints are owned by just a few collectors, books have a little bit of a larger group of collectors, and with NFTs there are even more.

BC: **Earlier you said that editing and sequencing are fundamental parts of your work, but with NFTs, all of that is basically irrelevant, as images often circulate on their own and without context.**

AC: With the first two platforms for photography, the print and the book, we understand how those outputs work. With a print, we understand the idea of texture, scale, the quality of the paper, the tonal range—you can tell a good print from a bad print. With photobooks, it's the idea of design, sequence, editing, the materials used. With NFTs, we're still developing the code for this new mode of output, an understanding of what makes it a unique iteration of the medium—what will make photographers excited to use it in their practice. It's inspiring to be at the forefront of trying to figure it out.

Bruno Ceschel is the founder of Self Publish, Be Happy.

Family Snaps

A trio of photobooks about domestic life reveals the home as a site of humor, performance, and self-fulfillment.
Lou Stoppard

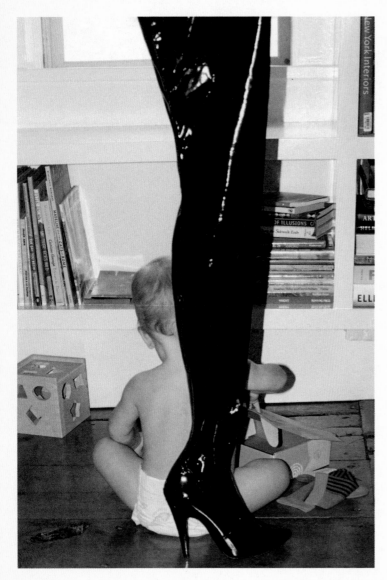

Talia Chetrit, *Boot/Baby*, 2020, from *Joke* (MACK, 2022)
Courtesy the artist

Throughout the pandemic, the popular conception of home became a place of unrelenting monotony—a site of confinement, despair, potentially even breakdown. Creativity was stifled when stuck in one's living room. It was impossible to maintain professional output while sharing a space with one's children. To many women, this new obsession with the inside, the domestic, was both frustrating and amusing. Home was now a space confining both sexes. And yet, female artists have long centered home as a site for probing discussions and creative explorations. The resultant works often deal with the themes that contributed to women's very presence at home in the first place: sexism, pay disparity, childcare inequality, patriarchal conditioning and control.

The domestic and, in turn, the family have been popular topics within the history of photography, as well as the subject of various notable exhibitions—for example, *Pleasures and Terrors of Domestic Comfort* at the Museum of Modern Art, in New York, in 1991, and *Who's Looking at the Family?* at London's Barbican, in 1994. Many of these were curated, in part, to redress the lack of female representation within museum shows, a fact that makes the included works'

commentary on the narrowness of women's opportunities and freedoms only more poignant. Women photographers were in the museum, and yet, somehow, still at home, in their place.

In the catalog for *Pleasures and Terrors*, which featured Ellen Brooks, Jo Ann Callis, Doug DuBois, William Eggleston, Cindy Sherman, Sage Sohier, and Carrie Mae Weems, among others, the curator, Peter Galassi, wrote that artists "began to photograph at home not because it was important, in the sense that political issues are important, but because it was there— the one place that is easier to get to than the street." The comment likely amused some female artists at the time but now reads as starkly unperceptive, if not blind to varied motivations in creative experience. This lack is especially obvious when one surveys just a few of the many new books and photographic projects dealing with home and domesticity: Talia Chetrit's *Joke* (**MACK, 2022; 128 pages, $55**), Csilla Klenyánszki's *Pillars of Home* (**Self-published, 2019; 148 pages, €30**), and Kuba Ryniewicz's *Daily Weeding* (**Note Note Éditions, 2021; 96 pages, €40**).

These image makers photograph home both because it is "there" (and was "there" more obviously than ever during the pandemic) and because it is "political" and "important," to use Galassi's aspirational words. Both Chetrit and Klenyánszki infer that the very fact of their both, as women artists and mothers, being "there" (at home, caring for babies) is, in itself, fruitful territory for the exploration of some of the most troublesome and limiting divisions, and habits of thinking, within society. Who is a mother? What behaviors make her good? What subjugations should she tolerate? What should she keep of herself? Can she be sexual? Can she be an artist? Who is a father figure? Is he at home too? What is home? In Chetrit's pictures especially, the send-up of familial tropes and domestic scenes, with humor and light irony, is enjoyable—an older man sits, legs spread, his chest hair showing through his mesh undershirt; a young father, wearing a dress with layers of yellow tulle, stands next to his baby; disembodied mannequin limbs appear on the page before a close-up of a caesarean scar.

The works made me think of Jo Spence and Patricia Holland's book, *Family Snaps: The Meanings of Domestic Photography* (1991), in which Spence asks, "The family album: what does it contain? What lies beyond the symbolic images of special events, occasions, celebrations, 'success'—particular weddings, the new baby, holidays, the 'happy family'?" Spence offers, "Perhaps, superficially, family albums tell us more about the accepted ways of picture-making, or what was considered appropriate at any historical

time, than they do about the particular family represented?" Chetrit's goal seems to be to revile "appropriateness," to thumb a nose at the serenity and wholesomeness that are expected in depictions of mothers, families, and children.

On the first page, we see a baby, naked except for a diaper, playing in front of a shelf of children's books (*Madeline and the Cats of Rome, Mr. Tiger Goes Wild*). In front of it, a single adult leg bisects the image, masking half the child: the leg wears a shiny black thigh-high boot. The combination of the supposedly pure and the latently erotic is designed to disarm, to nod to the many often irreconcilable fetishes that surround women—mother, sex object, Madonna, whore. Chetrit's picture is also funny, as a visual. I laughed when I saw it. Projects about home often deal with pungent dichotomies: prosperity versus compromise, safety versus violence. Chetrit composes such juxtapositions with refreshing lightness, refusing to be solemn, sentimental. The book's title here—*Joke*—is perfect. She finds the traditional stereotypes of family ridiculous. She will not dignify them with anger. Her humor is always more sardonic than slapstick, a little knowing, a little cool. The inclusion of high fashion in the images (Balenciaga jeans, a micro Chanel handbag) is unsurprising—Chetrit has photographed for various brands, such as Acne Studios and Celine—but contributes to the sense of insolence and chilliness. Such inclusions give the work an impenetrability, which in itself refutes the idealized vision of mothers as open, kind, soft, welcoming.

There is also wit in Klenyánszki's *Pillars of Home*, which makes a physical manifestation of the concept of *juggling*, a buzzword in so many conversations about domesticity and motherhood. The small-scale book features photographs of sculptures built from household objects during the photographer's baby's nap time. The statues are precarious: a baguette is about to snap under the weight of an umbrella, a pile of oranges is ready to tumble down. In *Pillars of Home*, Klenyánszki writes that, should the installation collapse, not only will the "existence of the image" be "in danger" but also "the noise of the fallen objects might awaken the sleeping baby, which puts an end to the working session." The book is a comment on limited freedom—on the way a child restricts options and hampers work, the way the family can smother the individual.

Looking at each sculpture, one imagines the forthcoming crash, a wail from an adjacent room, the rush of feet toward the cry as the objects shatter or roll, the vibrations spreading across the room. The best images are the ones where the fall seems certain and particularly violent: a vase of

Spread from Csilla Klenyánszki, *Pillars of Home* (Self-published, 2019)

flowers balances on an open door, a pair of splayed scissors sits vertically on top of the blooms. One knows it will come down. There is a shakiness and vulnerability that seems in keeping with the precariousness of our times. Everything we build, the supposed securities of home and family, can be swept away in a moment by external factors: pandemic, death, war, climate change, the cruelty and inexplicability of other people's choices.

Klenyánszki's book nods to the arguable irrationality of bringing a child into a collapsing world. One of the project's weaknesses—repetitiveness—is also its strength. By the middle of the book, the photographs, and sculptures, start to blend; one tires. It infers the relentlessness of child-rearing, of life in a small apartment, and, in turn, the relentlessness of worry, instability, crisis.

The monotony of crisis also underpins Ryniewicz's *Daily Weeding*, which was made during lockdown, and features images of friends and neighbors hanging out near high-rise tower blocks, gardening, or nurturing swollen pregnant stomachs. An accompanying text by Olivia Laing refers to "love in a tiny space." She wonders, "Could it still feel free?"

Writing in the introduction to *Family Snaps*, Holland argues that "making and preserving a family snapshot is an act of faith in the future." What all three books, but especially *Joke* and *Pillars of Home*, present is the family snapshot when that faith in the future is shaken, no longer rational or appropriate. They speak of an age of juxtapositions, dissonance, oddness—of uncanniness, within the home as everywhere. If the function of the family photograph has typically been to serve as propaganda for traditional systems, for conformity and the illusion of bliss, these works seek to unsettle, to gently mock. But they are not simplistic manifestos. All three books retain the deeply personal aspects, along with a sense of quotidian flow, that make domestic photography interesting. They are as much records of ambivalence as of anger, of acceptance punctuated by occasional flashes of thirst for self-fulfillment, authorship, and—the perpetual great threat to home and family—*more*.

Lou Stoppard is a writer and curator based in London.

Reviews

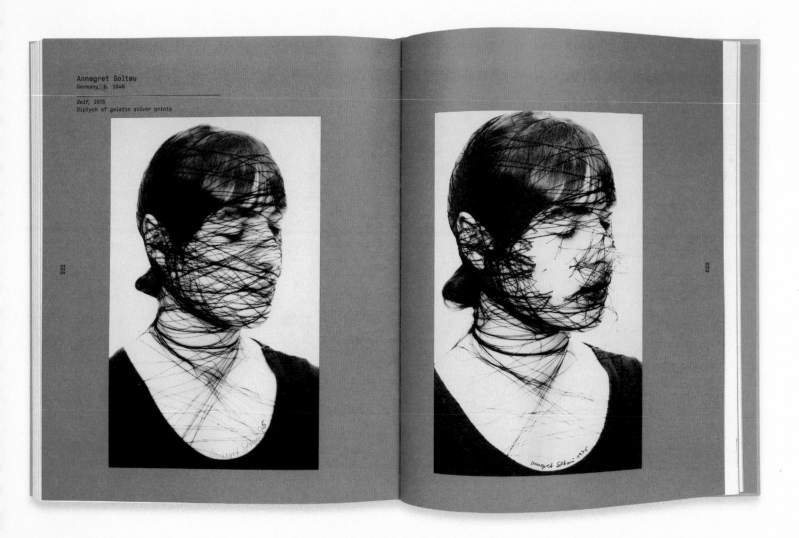

Annegret Soltau
Germany, b. 1946

Self, 1975
Diptych of gelatin silver prints

222 223

**Spread from *An Alternative
History of Photography*
(Prestel, 2022)**

An Alternative History of Photography

In the late 1970s, when asked about the future of photography, the German scholar Helmut Gernsheim said: "I don't think there are any major photographers left to be discovered." As unserious as the statement reads today, it illustrates an enduring tension. Originating in the heyday of European colonial expansion, photography has always wrestled with questions about how to better survey, assess, predict, and reflect on the medium's history. ***An Alternative History of Photography* (Prestel, 2022; 256 pages, $55)**, edited and compiled by Phillip Prodger, adds to this tradition while critiquing its relevance. "Gernsheim's mistake . . . was to think of photography as a great white whale," Prodger writes. "More properly, it is a heaving mass of wriggling eels, writhing this way and that and looping back on itself."

Drawn from the Solander Collection, with its emphasis on international and forgotten photographers, the book expresses a faith in photography's "grassroots character" and—aware of its own inherent subjectivity—gathers a wide selection of artists, both well-known and historically under-discussed, with commentary from curators and scholars across regions and research interests. Some highlights include the early twentieth-century New Zealand pictorialist Una Garlick; the studio practitioners Michel Kameni, from Cameroon, and his distant contemporary Lee Lim, from Singapore; and the pioneering Turkish photographer Yıldız Moran. Prodger is generally suspicious of the clamor for new masters and the market incentives that constitute accepted histories. The "alternative" in the title suggests the need for both an expansion and a rearrangement. There is no definitive framework, no great Moby Dick to be harpooned, but instead a thousand possibilities, and a lot of work left to be done.
—**Varun Nayar**

Zhang Xiao

Zhang Xiao's ***A Hometown*** (**Jiazazhi, 2021; 1,112 pages, €50**) is an engrossing, multidimensional exploration of the artist's hometown of Taishang Village in Shandong Province, China. An orange-and-pink marbled slipcase reveals a softcover volume of hundreds of photographs, printed on thin, uncoated paper and, appropriately, recalling an encyclopedia or field guide. There's no wasted space here; Zhang collects more than a dozen different projects to create an exhaustive, breathless compilation about his birthplace. Throughout the book, his fourth collaboration with the Ningbo, China–based publisher Jiazazhi, Zhang obsessively notes how China's rapid urbanization has transformed the social, cultural, and economic landscape of the rural village. Delving into his own ambivalent feelings of estrangement after returning home from making work in Chongqing and along China's southern coast, Zhang produced a wide range of photographic experiments. Some appropriate the images of local photography studios to capture the aesthetics and aspirational tastes of the community, while others, such as a series of Polaroids that records every item stored in the drawers of his childhood home, tell a personal story of memory and longing.

At both the literal and thematic core of *A Hometown* is a smaller book within a book that contains a straightforward, documentary approach to the exploration of Zhang's town's terrain and its agricultural economy. While the included projects have various styles, the constellation of work that the book presents feels cogent and revelatory. Accompanying the photographs are four pieces and an interview with the artist. "The 'hometown' here is no longer just an individual concept for me," Zhang notes. "I hope to expand the scope of it to a collective sense." Perfectly balancing a simplicity of form with the intricacy of its content, *A Hometown* is a comprehensive, shifting, and ever-surprising study of homecoming. —**Noa Lin**

Sem Langendijk

Sem Langendijk grew up in an abandoned rail station on Amsterdam's waterfront. You could call it the hinterlands, but the Westerdok, a former cargo-loading station, is a stone's throw from the Centraal Station, where commuters come and go and tourists are whisked off to Schiphol Airport. At the time, in the 1980s and '90s, the

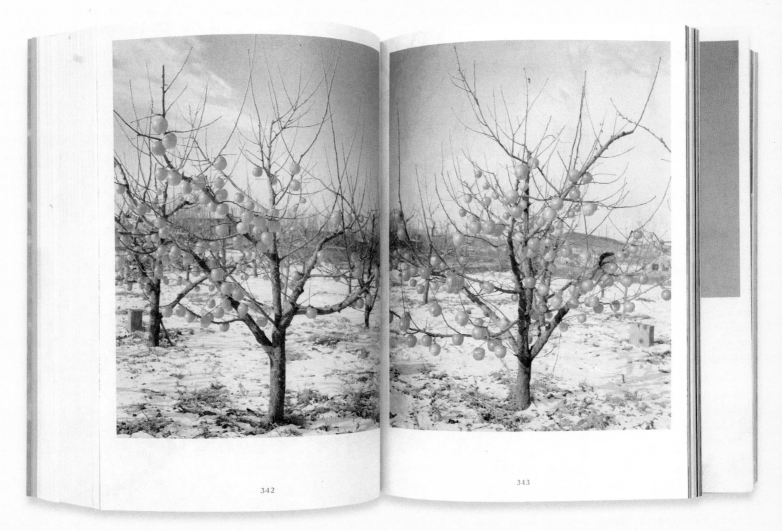

342

343

Westerdok was settled by a community that transformed the building into homes and art studios. Langendijk played in the gardens planted around the quay's tracks, and his parents made a bedroom in an old ticket office. Then, on the hinge of the new millennium, the idyll was destroyed and the community scattered, all in the name of development and regeneration. "By the time I realized it was a special environment, it was already gone," Langendijk says, an experience that became the motivation for **Haven** (**The Eriskay Connection, 2022; 152 pages, €38**), a book about cities in transition.

For six years, beginning in 2014, he photographed industrial and fringe neighborhoods in Amsterdam, New York, and London, creating a meditative profile of urban deterioration, growth, joy, and memory, united by a velvety, sun-stippled color palette that suggests the influence of the photographers Jamie Hawkesworth and Gregory Halpern. There are falling-down buildings and graffiti, construction cranes and glassy skyscrapers, yet Langendijk resists the archaeological spectacle of picturing ruin as devoid of emotion. His portraits are, likewise, empathic. His subjects, with their beards, tattoos, and overalls, appear as characters in a short story. None of the photographs are captioned or dated, including the typologies at the book's conclusion (fast-food shops, shipyards), which form a visual conversation with the writer Taco Hidde Bakker's essay on gentrification, an account of what we might lose when the "intense mingling" once characteristic of urban life disappears in the quest for a bright, shiny future. —**Brendan Embser**

Top:
Spread from Sem
Langendijk, *Haven*
(The Eriskay Connection,
2022); bottom: spread
from Laia Abril, *On Rape:
And Institutional Failure*
(Dewi Lewis, 2022)

Laia Abril

On Rape: And Institutional Failure (**Dewi Lewis, 2022; 228 pages, $52**), the second chapter in Laia Abril's ongoing series *A History of Misogyny*, follows her audacious first volume, *On Abortion* (2018). Abril's handling of these interlinked subjects epitomizes a research-driven approach to visual storytelling and the effectiveness of the book form as a means of presenting such investigations. Her black-and-white images are often forensic and quasi-typological in nature—dresses and military uniforms, medical devices and handcuffs. Each is supported by women's firsthand accounts of their experiences with sexual violence. Historical notes detail the appalling ubiquity of rape as a means of exacting androcentric control over women and their bodies, documenting a range of practices, from rape camps and honor killings to the most contemporary manifestations, revenge porn and meta-rape (the virtual gang rape of a user's online avatar).

Abril underscores the pervasiveness of sexual violence, weaving together excruciating stories, from Afghanistan and Argentina to South Africa and the United States, as well as including interviews with women's rights advocates. She identifies how laws and institutions around the world fail women time and time again, pointing to how those structures might be changed to better protect the right of women to bodily autonomy and sexual self-determination.

If the collection sometimes feels scattered, it's for the bar having been set incredibly high by Abril's effort to cast the